Women see Woman

Women see

Woman

Cheryl Wiesenfeld
Yvonne Kalmus
Sonia Katchian
Rikki Ripp
editors

Art direction by
Geri Davis

THOMAS Y. CROWELL COMPANY
New York Established 1834

Library of Congress Cataloging in Publication Data
Main entry under title:

Women see woman.

1. Women—Social conditions—Pictorial works.
I. Wiesenfeld, Cheryl. II. Gottlieb, Annie.
HQ1154.W885 778.9'9'301412 75-16410
ISBN 0-690-00965-8
ISBN 0-690-00972-0 (pbk.)

2 3 4 5 6 7 8 9 10

INTRODUCTION

The art of photography and the active and conscious claim by women to the sovereign right of self-definition are both distinctly modern phenomena: in fact, they are almost of an age. In 1839, William Henry Fox Talbot in England and Louis Jacques Mandé Daguerre in France independently announced the invention of photographic image-fixing processes; just the year before, in America, Sarah M. Grimké had published *Letters on the Equality of the Sexes and the Condition of Women*, and so became "the first American woman to publish a cross-cultural examination of the condition of women and a reasoned feminist argument against the injustice of that condition."[1] The first Woman's Rights Convention was held at Seneca Falls, New York, in 1848, and the Royal Photographic Society of London, open to both men and "ladies," was founded in 1853. The American Civil War became, in very different ways, a focus for the development of photographic documentation and of feminism. The art and the awareness have matured side by side—independently, to be sure; but both belong to the modern sensibility, and it is natural that women, in the era of their increasing independence and self-scrutiny, should have turned to the camera, an instrument for the direct expression of personal vision and for creative engagement with the "real world."

Women have been involved in photography from its very beginnings, despite the obstacles nineteenth-century culture presented to their serious participation in any art or profession—much less one that involved

[1] *Root of Bitterness*, Documents of the Social History of American Women. Edited, and with an introduction by Nancy F. Cott. E. P. Dutton & Company, New York, 1972.

technical expertise and cumbersome equipment. Constance Talbot, wife and photographic helpmate of the British inventor, was "the first woman photographic technician and the first woman photographer"[2] — as well as the first of a long line of women who were to learn photography from their husbands (or fathers, or lovers) and then, in some cases, to surpass them or take over the business from them. Other early women photographers, like Gertrude Käsebier, boldly apprenticed themselves to male professionals to learn the technical essentials. (Contrary to stereotype, women have never been intimidated by the technical aspects of photography. Berenice Abbott wrote books and articles on equipment design improvement, and younger women photographers have been among the most persistent experimenters with new technology.) Käsebier, who did not become a photographer until her children were nearly grown and who vividly described the hindrances of convention when she wrote of going down to the river to wash wet plates despite "dragged skirts and wet feet," could still write, in 1898: "I earnestly advise women of artistic tastes to train for the unworked field of modern photography. It seems to be especially adapted to them."[3] And Frances Benjamin Johnston, an unconventional and ambitious photojournalist, wrote articles in the late 1890s on "What a Woman Can Do with a Camera" and on "The Six Foremost Women Photographers of America."[4] Technical advances kept pace with and facilitated the growing enthusiasm of women for the camera: the invention of flexible film and the hand camera in the late 1880s opened the field to enthusiastic amateurs, many of them female.

All in all, as John Szarkowski of the Museum of Modern Art has written, "Women have been more important to photography than their numbers would warrant."[5] Perhaps this is not, as he mischievously suggests, because photography itself has something "receptive, or passive" about it (he admits that accomplished women photographers have had little that is passive about *them*), but because an art so new was not surrounded by entrenched taboos or possessed by the mystique of brotherhood; was not, for that matter, taken seriously as an art, anymore than women were taken seriously as artists. This gave women a paradoxical advantage in gaining a foothold, and as photography ceased to imitate painting and attained the status of an art form in its

[2] *Women of Photography, An Historical Survey.* San Francisco Museum of Art. 1975.

[3] Quoted in *The Woman's Eye*, edited and with an introduction by Anne Tucker. Alfred A. Knopf, New York, 1973.

[4] *Ibid.*

[5] *Looking at Photographs, 100 Pictures from the Collection of the Museum of Modern Art* by John Szarkowski. The Museum of Modern Art, New York, 1973.

own right, women were prominently, if not equally, represented. By 1910, eight years after its founding, over one-fifth of the members of Alfred Stieglitz's Photo-Secession were women, and the first issue of its magazine *Camera Work*, in 1903, had featured the work of Gertrude Käsebier—of whose photographs, so many of which dealt with themes of motherhood and childhood, Stieglitz ironically wrote, "Their strength never betrays the woman."[6]

That may begin to give some idea of what women photographers have confronted, and still to some extent confront, in their struggle to achieve professional status and recognition. Until—so recently—conventions genuinely began to change, the woman who chose an art or profession was necessarily an anomaly both among women and among professionals. She had to have the courage and drive (and, if she was lucky, the social position and emotional support) to defy persistent norms of female behavior; if she took refuge in the art world, she might find her unconventionality and even her ability accepted, but her womanhood subtly denigrated. If she achieved recognition, she was likely to be reminded in a thousand small ways that she had succeeded in spite of being a woman—an essential part of her being split off and accorded at best incidental status. She often faced the woman artist's classically guilt-ridden conflict betweeen the time-devouring responsibilities of a family and the commitment to creative work: a dilemma which some, like Käsebier, Alisa Wells, Diane Arbus, and Eva Rubinstein, resolved by deferring or not even discovering their need to create until their children were older; others, like Margaret Bourke-White and Berenice Abbott, by single-minded dedication to their work; Dorothea Lange and Judy Dater, by marrying colleagues with whom they could work and who encouraged their professionalism; a rare Barbara Morgan, by a temperament and set of circumstances felicitously suited to "total living." And finally there was the persistent problem of inequality in work opportunities and pay, which made it even more difficult for a woman photographer to support herself than for a man. But material obstacles and social resistance are the lot of any aspirant in the arts; what has hampered women far more insidiously than any external circumstance is their ingrained and constantly reinforced lack of conviction that what they do is important.

The few who possessed the drive and summoned the conviction to surmount these obstacles have distinguished themselves in every field of photography, including some that might have seemed unlikely: industrial photography (Laura Gilpin, Margaret Bourke-White), architectural photography (Frances Benjamin Johnston), scientific photography (Jeannette Klute, Berenice Abbott), photojournalism (Jessie Tarbox Beals, Johnston, Bourke-White, Mary Ellen Mark), social documentation (Beals, Doris Ulmann, Dorothea Lange, Marion Palfi).

[6]*Women of Photography. op. cit.*

Margaret Bourke-White was a great war correspondent, able to endure the same physical rigors as the soldiers she photographed; and some women photographers from sheltered backgrounds, like Palfi and Diane Arbus, seem to have used the camera not only as an instrument of compassionate scrutiny but as one of daring—daring to confront and experience every aspect of life.

Besides demonstrating that they are capable of risk and achievement in the same fields as men, women have undoubtedly brought resources of their own to photography. The traditional assignment of women to the sphere of relationship and the home has refined interpersonal perception to a high art in itself, and it is probably no coincidence that recently, a striking majority of professional women photographers—including Frances Benjamin Johnston, Jane Reece, Imogen Cunningham, Dorothea Lange, Lotte Jacobi, and Florence Henri—made their living by running portrait studios. (It is a measure of the greater variety of opportunities open to women today that the majority of the women represented in this book support themselves either by free-lancing or by teaching, or both.) Many of these women made loving and revealing portraits of the great artists of their time, which are both invaluable gifts to history and poignant expressions of the longing to participate in genius. Women documentarians like Dorothea Lange were able to reveal subtle aspects of their subjects' experience through their awareness of the expressiveness of gesture and environment.

Still, they were few. Out of 100 photographs in Szarkowski's selection from the Museum of Modern Art, only 13 represent what he calls the unwarrantedly influential contribution of women—a percentage, he suggests, already much greater than that of women in the general population of photographers. (The experience of the editors of this book challenged that suggestion, at least for today, as we will see.) And it is understandable that, of these relative few, most have not wished to be specifically indentified as *women* photographers or to explore the subject of womanhood in great depth. To be sure, some, like Frances Benjamin Johnston, Berenice Abbott, and Margaret Bourke-White, have encouraged and assisted other women to achieve; Dorothea Lange published *The American Country Woman* in honor of those women whose achievement was survival, dignity, and hardihood, and Nell Dorr photographed the sensual and tender relationship between mother and infant. But an artist—or journalist or documentarian—seeks unqualified access to human universals, and the prefix "woman" (like the suffix "-ess"— has always been a qualifying, restricting, and condescending one, just as the female experience has been regarded as a special and subordinate case of the human. To explore this experience, then, would have been not only to engage in a faintly disreputable enterprise but in a dangerous one: it was to risk violating men's ideas of women—which were, and are, dearly held. Small wonder that the best women photographers have simply (and quite rightly) been proud to be counted among the best photographers, and that the fact of their

womanhood has rarely been considered a vital component of their greatness.

All this is changing, and changing because the feminist movement has finally reached the "critical mass" to define its own dignity. A total reevaluation is taking place, in which women are beginning to examine the fact of being female itself—including the pain of being female in a male-oriented culture—as a positive ground, an untapped resource, and an access route to full humanity. This enterprise depends utterly on women's support and encouragement of each other, as fellow artists, as audience, and as critics. But it does not mean the confinement of women to the subject of woman, or a separatist art for a separate audience. It means the fearless grounding of women's humanity, and women's art, in the truths of their experience. Being free to examine and to honor that experience is likely to unlock the creativity of women photographers and other women artists in unsuspected ways in which it may have been inhibited before, and so to make possible the discovery of insights of value to all of humanity. This book is part and signal of that enterprise.

Women See Woman had its beginnings in the spring of 1973 in the mind of Sonia Katchian, a widely published free-lance photographer who was teaching a class of women photographers. In talks after class, she found that her students shared her frustration at not being represented in the major photographic annuals—except as wet-lipped, long-stemmed fantasies or as erotic landscapes in the "Dune-Breast" tradition. It struck Sonia that an annual composed entirely of the work of women photographers would both provide a much-needed opportunity for exposure and create an exciting occasion for exploration and interchange. She took the idea to Cheryl Wiesenfeld, who was then working at *Popular Photography.*

Cheryl had seen the problem from the other side. She knew there must be "a lot of women photographers out there," but she rarely saw their portfolios, and when women did bring work in, they were often timid and defensive. One issue of all women photographers had been planned at *Popular Photography,* but had been killed after two and a half months of work. Cheryl felt that women were discouraged from submitting their work by the policies they sensed behind the kinds of of pictures they saw in print (most of the people in top positions in photographic publishing are male), and she was intensely curious to see what women photographers were doing. She thought a women's photo annual was a terrific idea, and joined Sonia in the planning. They sought out two other women to complete the editorial team: Yvonne Kalmus, who brought experience in publishing and a keen eye for exhibiting and combining photographs, and Rikki Ripp, who had experience in book production and photographic reproduction and contributed her finely tuned sensibilities from the visual arts. It took

them a summer of thought and discussion to define the project, and even then, they had to wait for final direction from the photographs themselves.

In the fall of 1973, they took a post office box in Radio City Station, New York City—one that had formerly belonged to a quiz show—and started looking for an art director. They were fortunate in finding Geri Davis, who was then an art director at Harcourt Brace Jovanovich. Geri contributed not only her excellent technical and artistic skills but also her high enthusiasm for the project and her willingness to devote her own time to it in spite of her considerable responsibilities at Harcourt.

Before the project was fully underway, the photo annual metamorphosed into *Women See Woman,* a single book of the work of contemporary women photographers. After unsuccessfully seeking funds from foundations and corporations, the editors realized that the expenses of producing, promoting, distributing, and sustaining an annual would be prohibitive—at least for now. The energy and quality of women's enterprises is, frustratingly, still unmatched by the availability of resources.

A press release inviting submissions—a maximum of twenty-five prints per photographer, no entry fee required—was sent to galleries, colleges and universities, art publications, and individual photographers, and the request was spread by word of mouth. The response: a deluge that overflowed that post office box—during the last two weeks before deadline alone, it filled *ten* large U.S. mailbags! They received over 10,000 photographs from all over the country. The senders ranged from established and *even* eminent women photographers to women who had never published before. The quality of the images ranged from "very, very good" to bad—few were mediocre—and enough were very, very good to make the process of selection a collective torment and revelation.

For reasons of size and structure as much as of principle, the editors had decided to confine the theme of the book to "Who, what, and where woman is and where she is going." This restriction elicited protests from (or was blithely ignored by) quite a few of the photographers who submitted their work. "Women as photographers do not necessarily take pictures only of other women," wrote one. "We are interested in all the world, not just woman's 'place' in the world." She is right; and yet the work of re-visioning her own image, taking command of the way she is *seen,* is necessary groundwork for any woman declaring herself as a seer, whether or not it is the subject of her work. We are all raised to be seen, to chaperone our own appearance, to make sure it conforms to an acceptable outer image rather than revealing a spontaneous and treacherous inner reality. Rikki remembers being photo-

graphed by her photographer father, and hating it. Sonia remembers wanting to model for Sears Roebuck. A woman who steps out on the street to take pictures, or who confronts a portrait sitter over a camera, is (so far from being "passive") daring and demanding to be seen as active and even covetous and voyeuristic, a challenging subject rather than a "nice" object. Making truthful and many-dimensioned images of women is one way of affirming her inner sense of her self, breaking the grip of the male fantasy image that has so constrained women and so finally freeing them to be "interested in all the world." The editors of *Women See Woman* hope to be able to do future books—or even an annual—exploring the wider spectrum of women's vision.

In this exhilarating first sampling, the editors felt privileged, if also mind-boggled, "to have insight into the minds of so many hundreds of women." Sonia said thoughtfully that she believes "our original hypo-thesis that women do *see* differently was confirmed." But it was con-firmed in ways that no one could have predicted—and that no one can yet quite define—and it was confirmed in diversity, rather than in uniformity. Did any common themes, images or preoccupations emerge? "Nude self-portraits—*strange* ones," attempts to make images of self that were somewhat abstract—most of them from the waist up." *Rooms*—"We were puzzled," said the editors, "at how insistent this theme was. We had a whole section called 'Interiors.'" (Plenty of intrigu-ing possible explanations here to tickle the analytical faculty, from Erik Erikson's dubious concept of "inner space" to, simply, the traditional intimacy of women with the home.) Sensual, rather than erotic, nudes of both sexes. Still lifes in which attitudes were expressed obliquely or symbolically through objects. There were surprisingly few images of childbirth, of mothers with children—or of women with pocket-books! It is unavoidable that the editors will to some extent have im-pressed their own values on this selection, but the only deliberate editorial exclusion they have made is of images (and there were many) that were grotesque, cruel, or mocking, expressive of self-hatred.

The editors sometimes disagreed about what merited inclusion, and the book represents "a reconciliation of all our tastes, not a compro-mise." It is also designed to reconcile, and as nearly as possible to unite, the two aims of making a statement about "woman as a human being" and making a book of good photographs. It does not claim to be a comprehensive or inclusive survey of accomplished women photog-raphers; among those whose work the editors much admire, but were unable to include, are Berenice Abbott, Imogene Cunningham, Lisette Model, and Marion Palfi. This book does, however, suggest the wealth and the range and the surprising qualities of vision of women who are making images in America today.

—Annie Gottlieb
New York City, 1975

Women see Woman

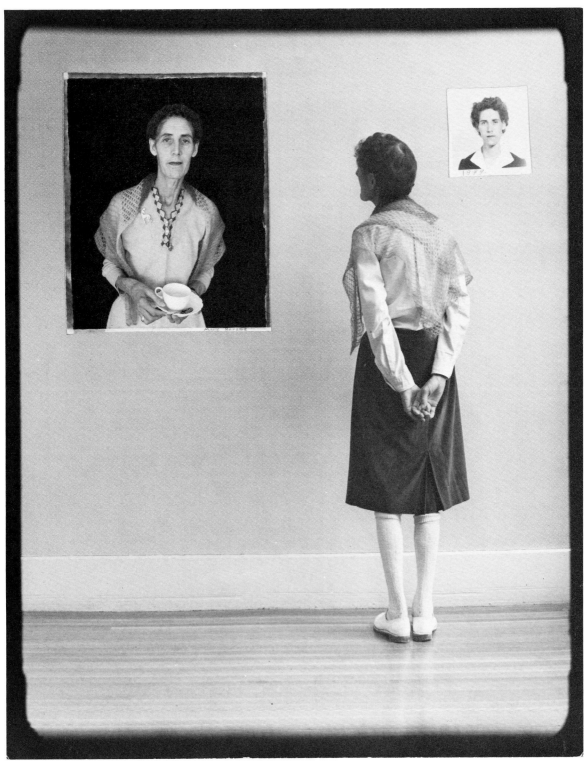

Wendy Snyder Macneil

We are given the Image like a task, a cruel riddle
with no solution. It is our responsibility,
our burden, our bewildered pride. We accept; we
collaborate; we even succeed. Why this pain?

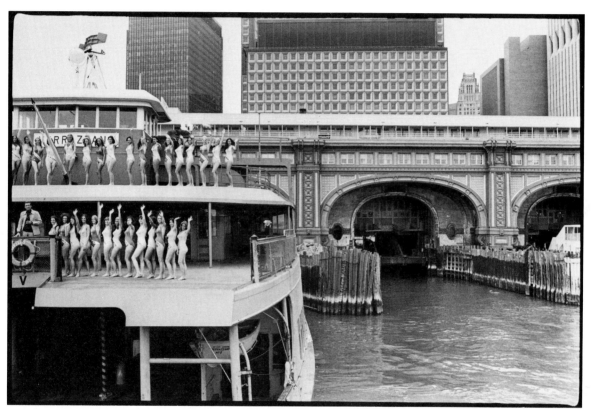

Susan Angus

3

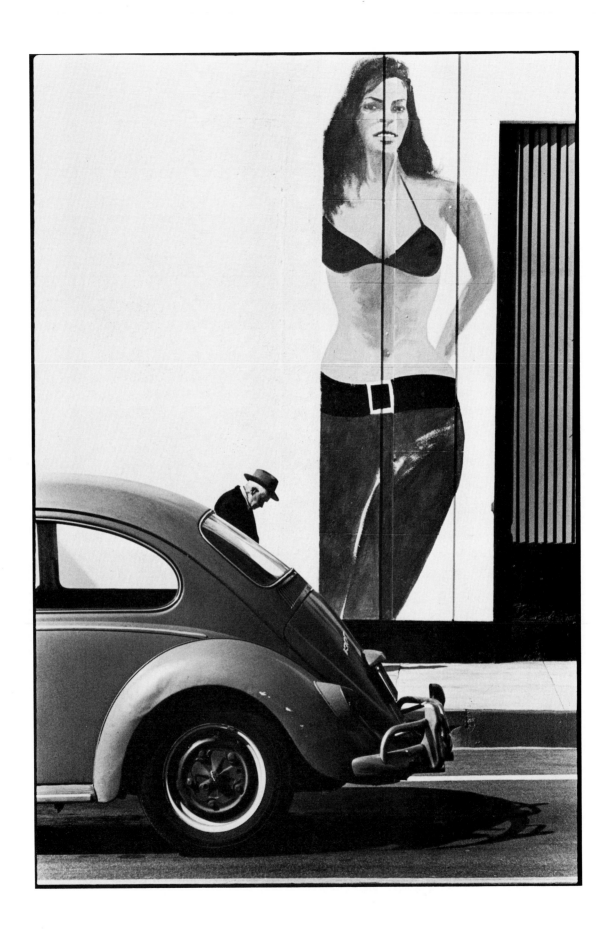

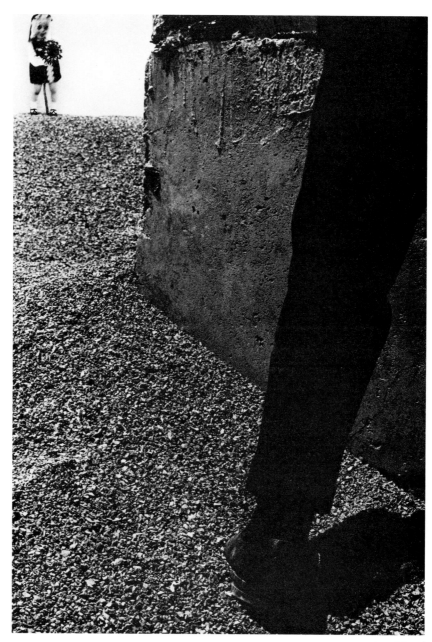

Eileen K. Berger

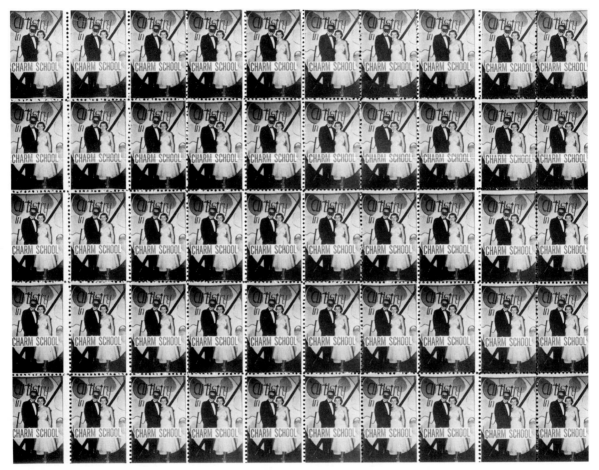

Pat Tavenner

6

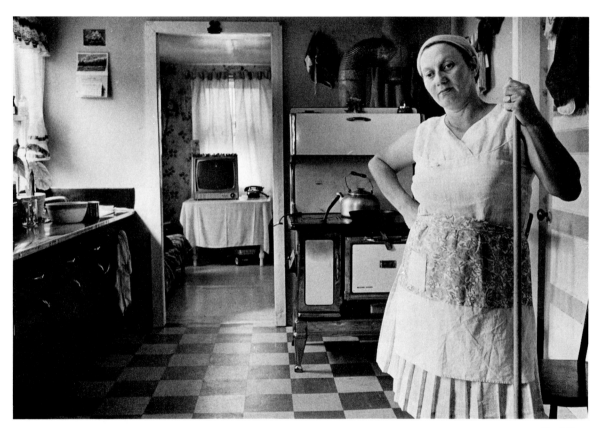

Pamela Harris

7

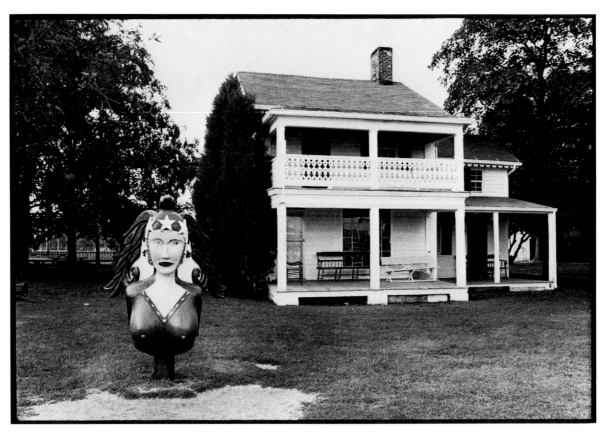

Claire Henze

8

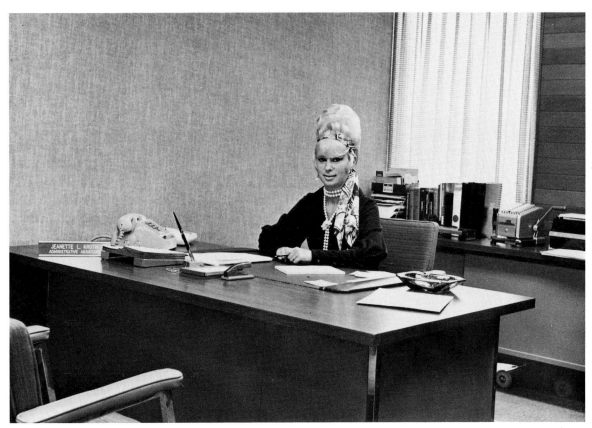

Martha Haslanger

9

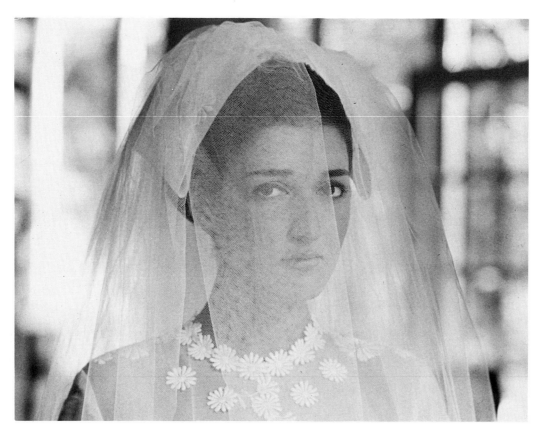

Suzanne Szasz

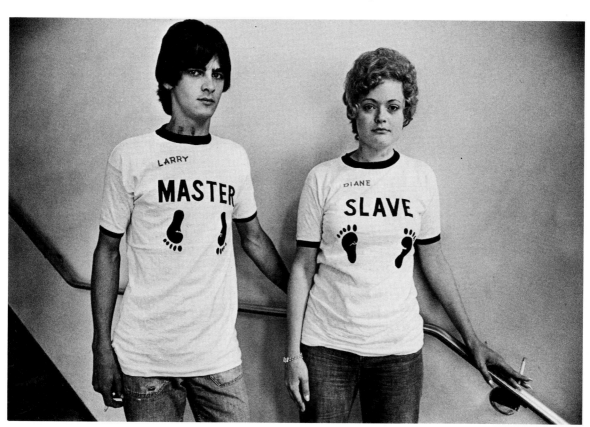

Jodi Cobb

11

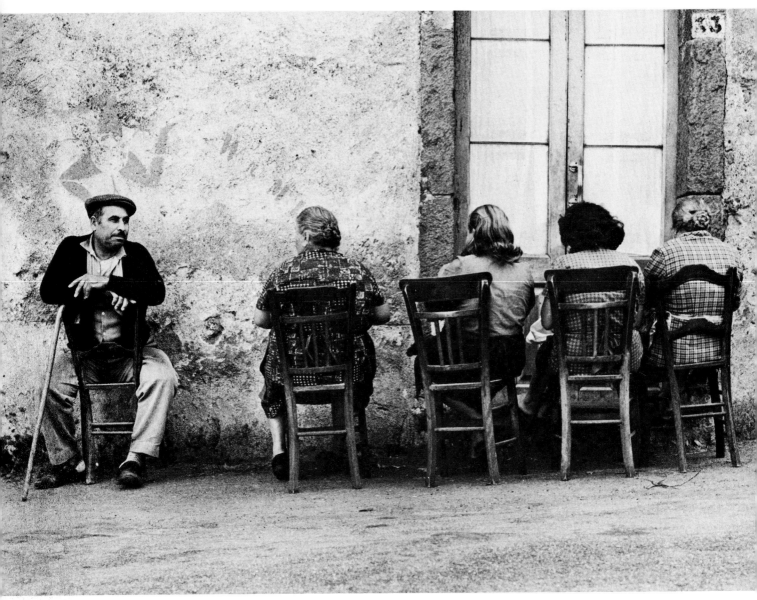

Lisl Denis

12

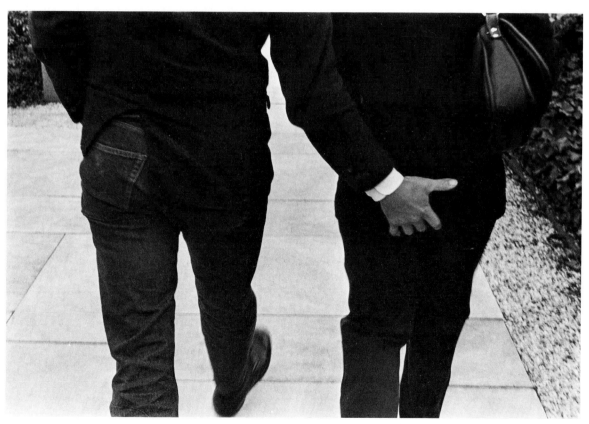

Anne Tucker

13

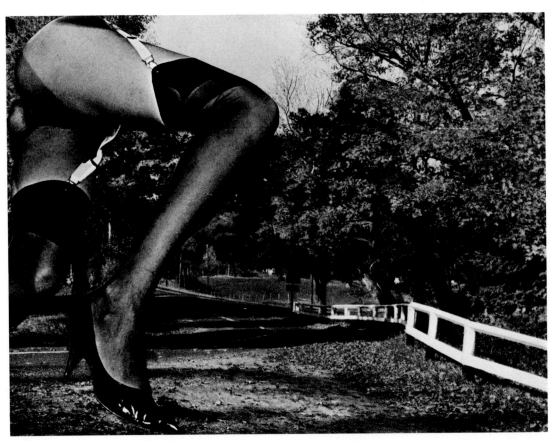

Linda Connor

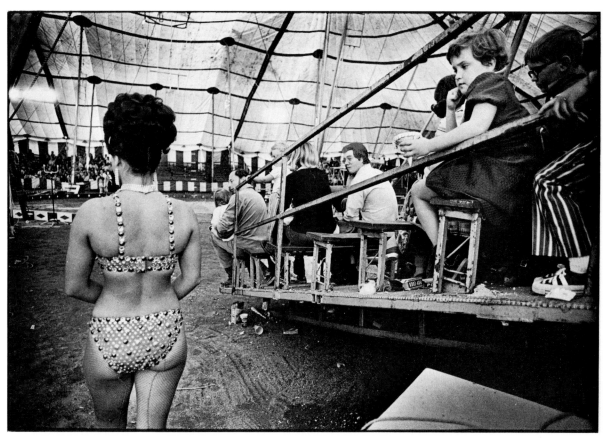

Jodi Cobb

15

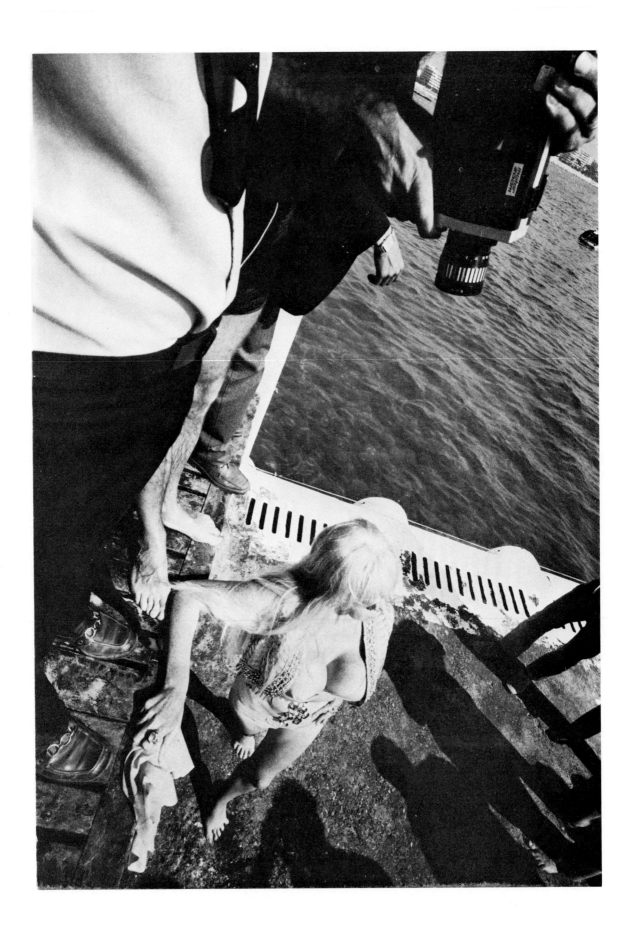

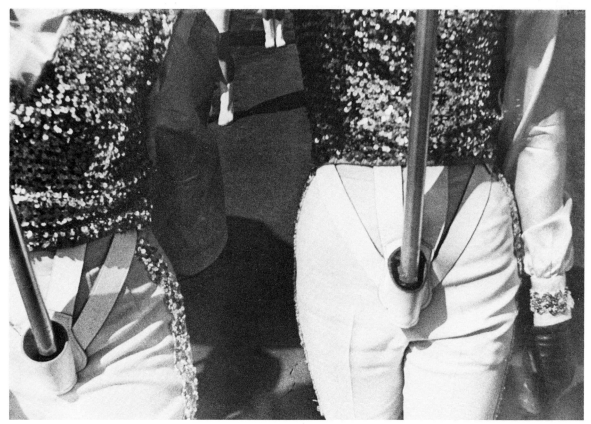

Jill Freedman

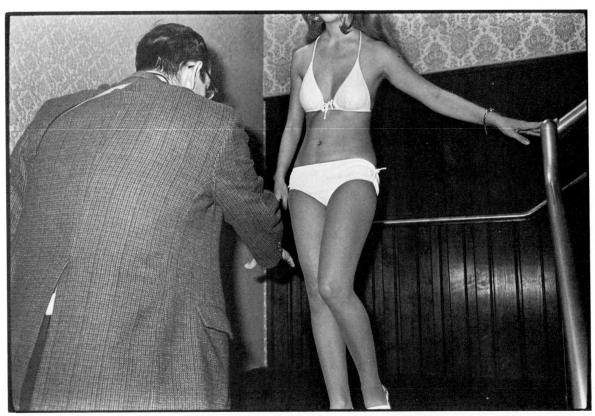

Susan Hacker

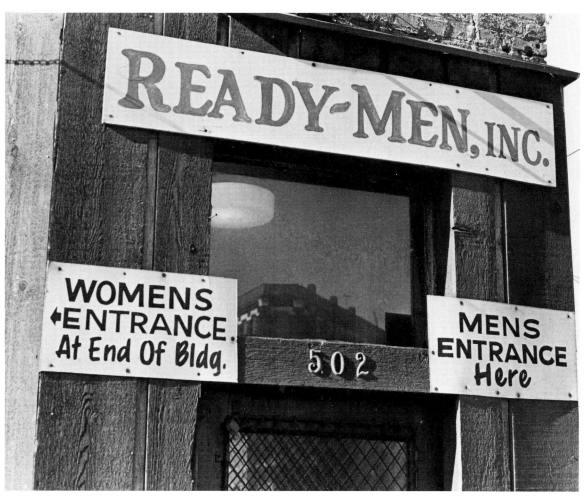

Dorothea Jacobson

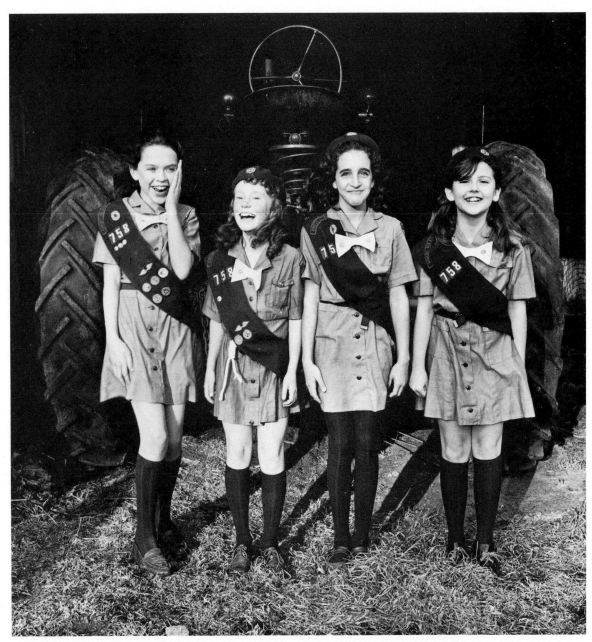

Lauren R. Shaw

20

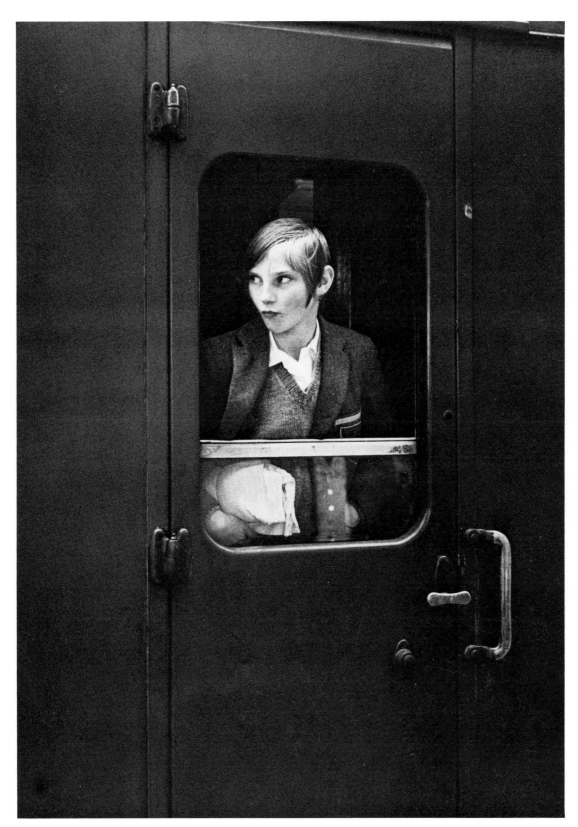

Eva Rubinstein

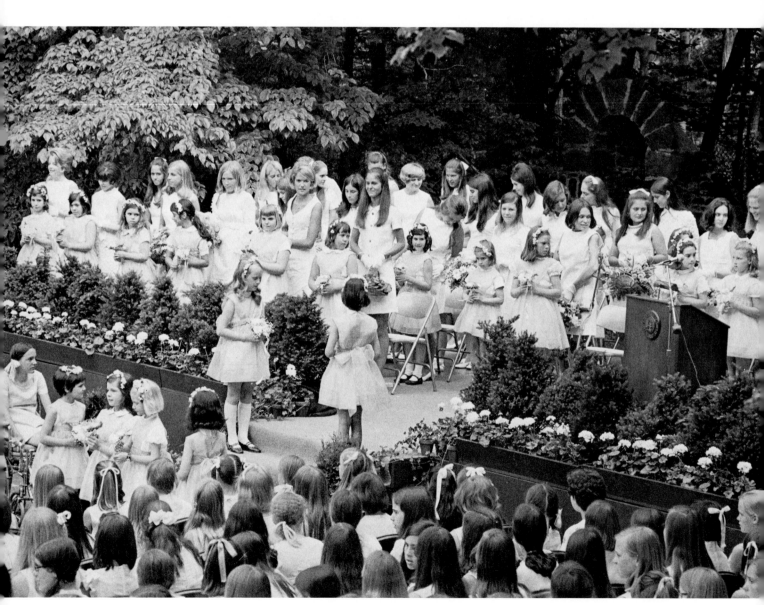

Suzanne Szasz

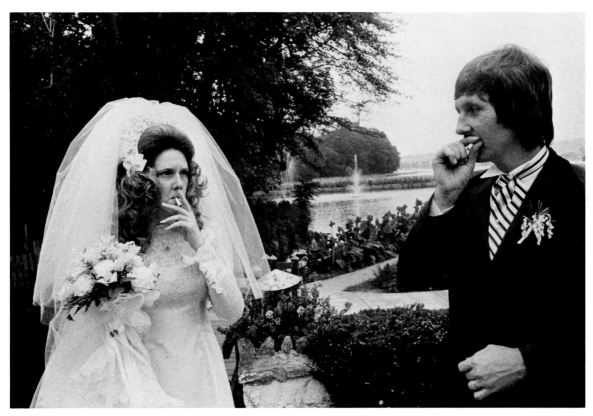

Sardi Klein

23

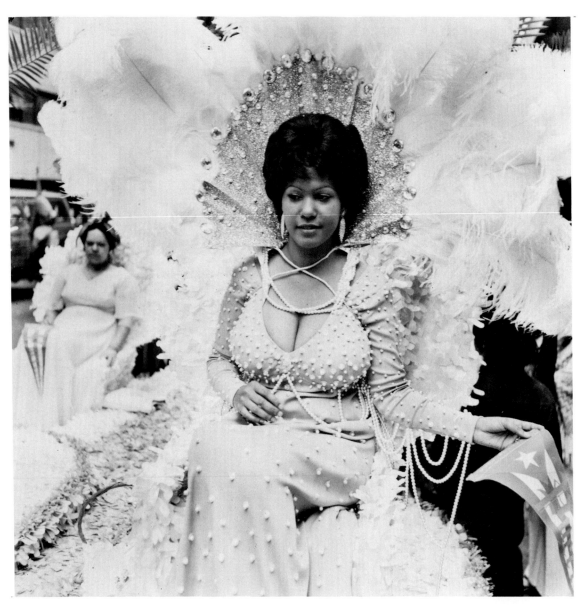

Susan Opotow

24

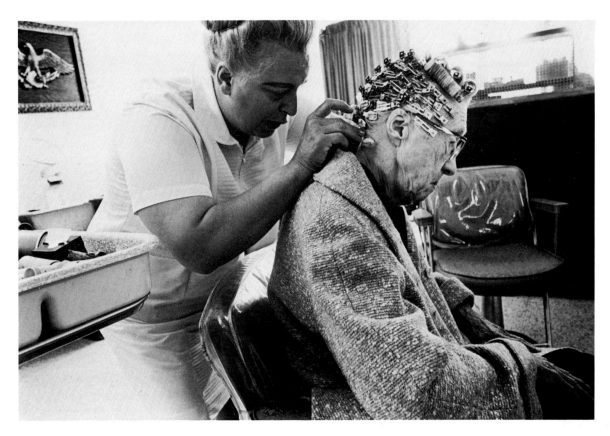

Susan R. Mogul

They call ships "she," too. The little men in her belly; the gynecologist's fingers. A female Gulliver strapped down in Lilliput.

Virginia Hamilton

27

What am I?
I am very much alone.

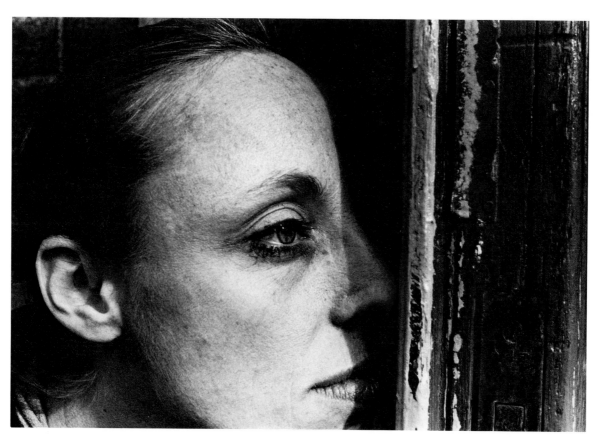

Helen McMullen

29

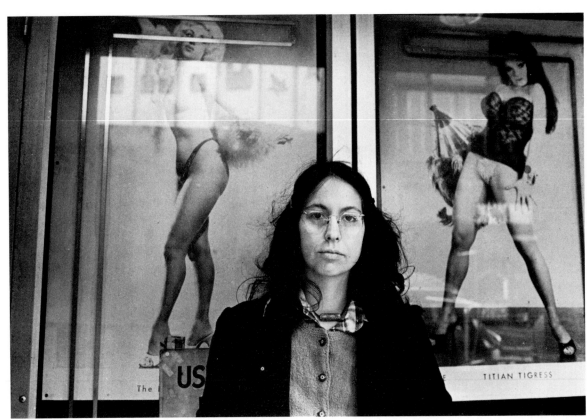

Eileen Friedenreich

30

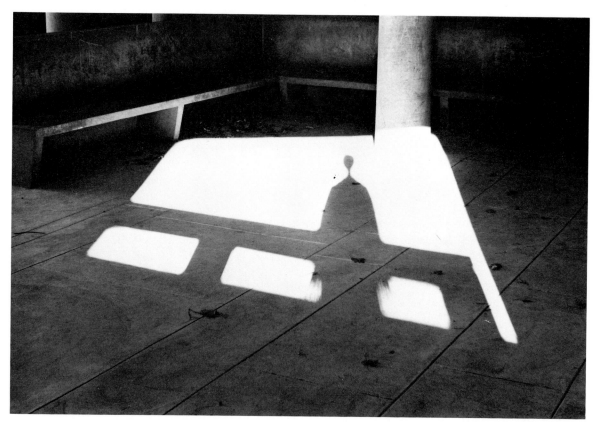

Elaine Fisher

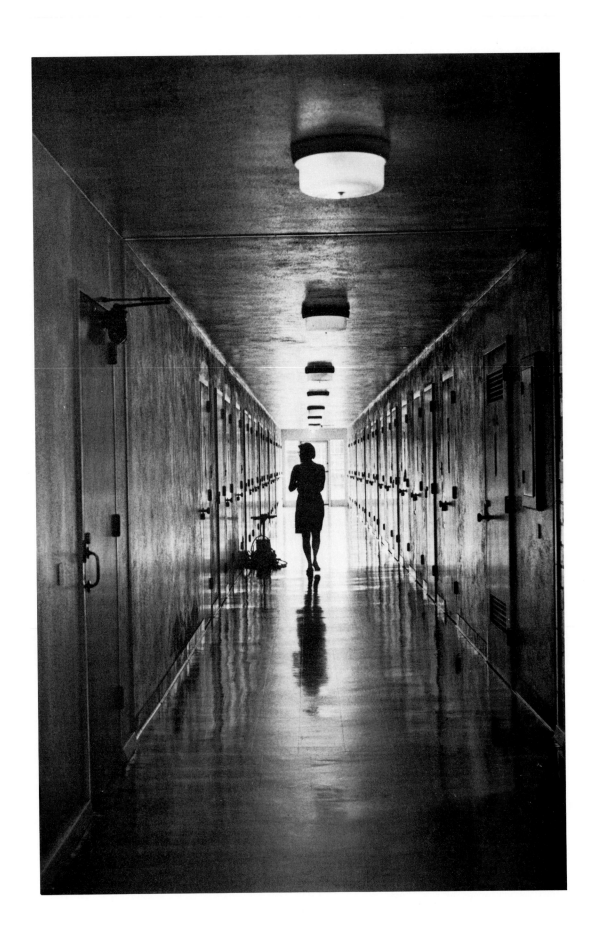

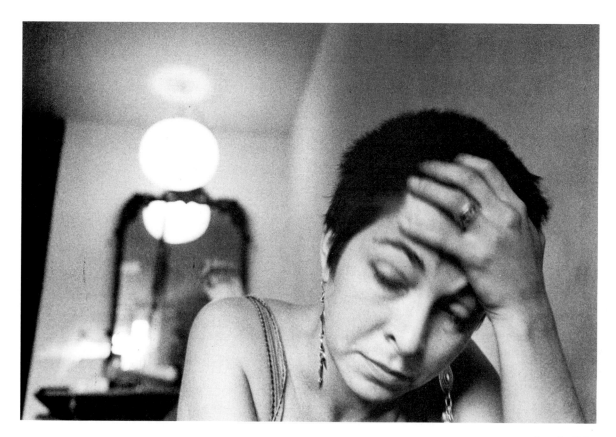

Donna Lee Phillips

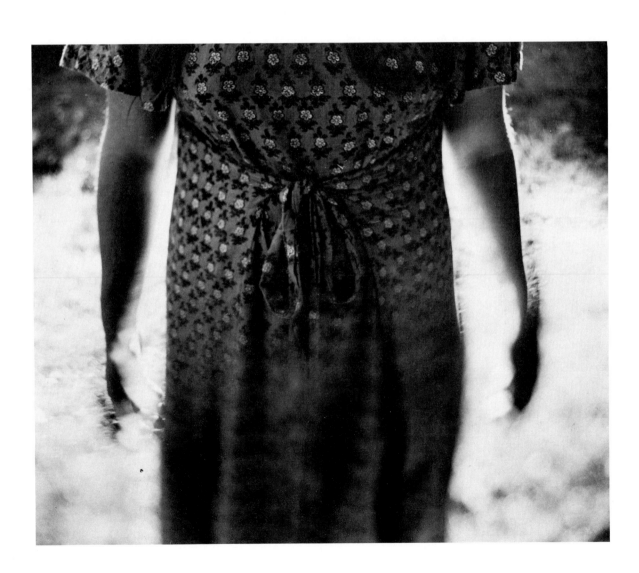

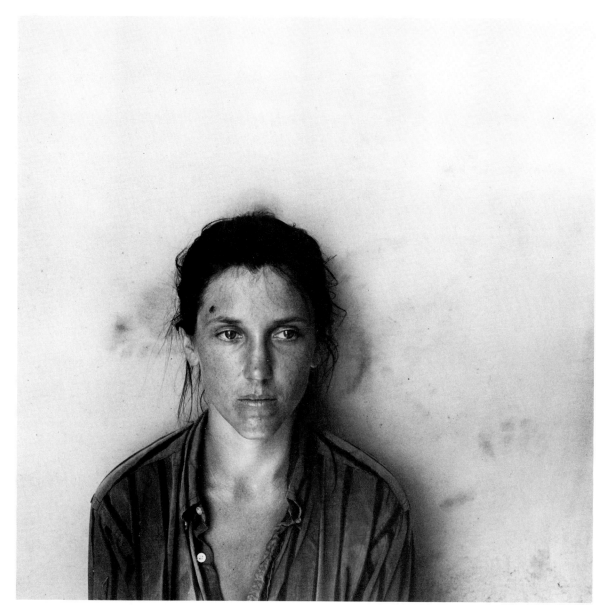

Suzanne Paul

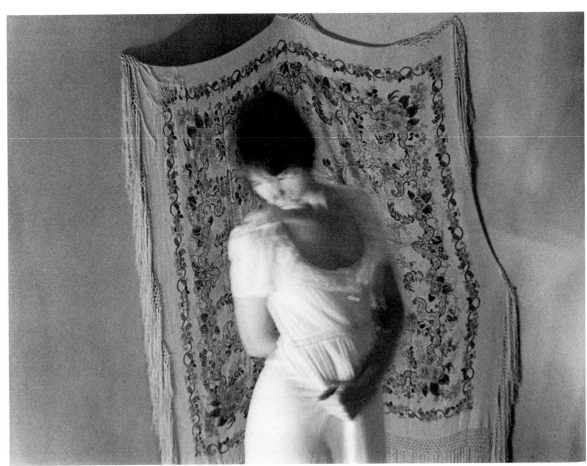

Alida Fish Cronin

36

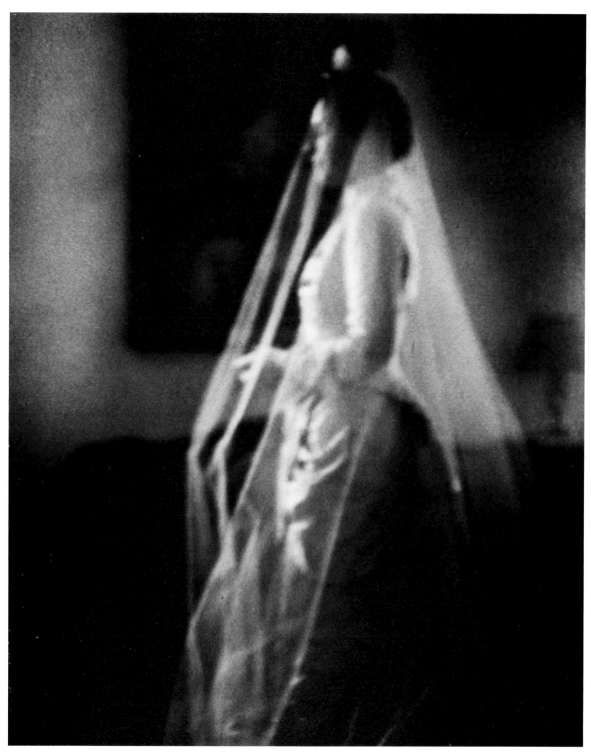

Nell Dorr

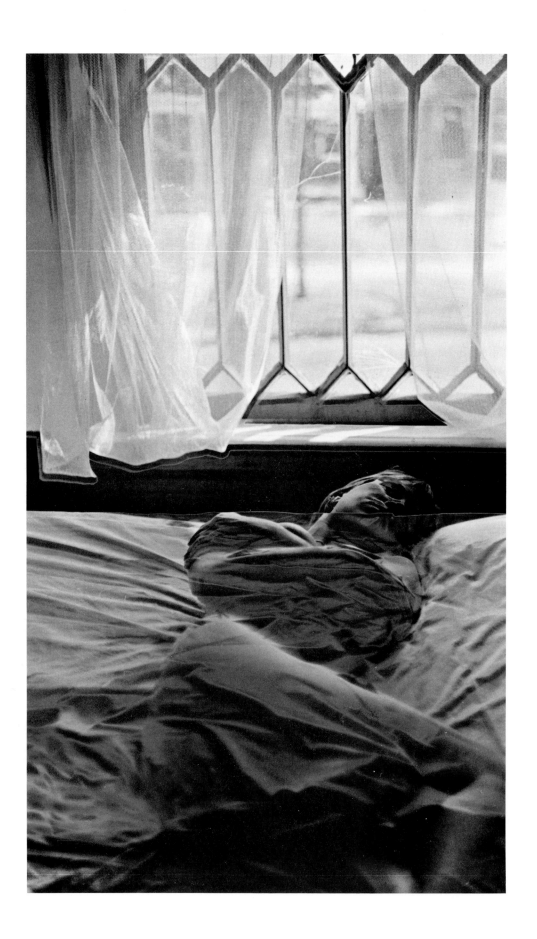

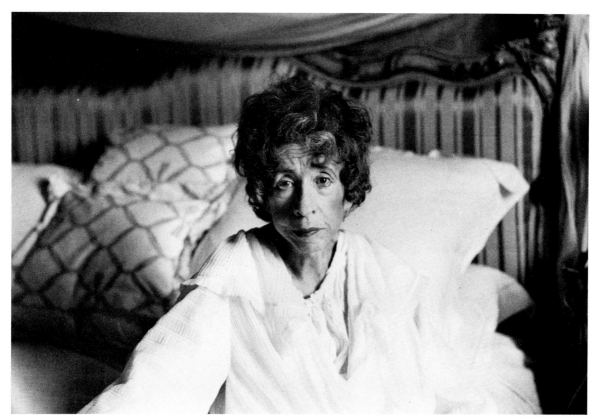

Eva Rubinstein

It is a life of hard work and small comforts, of
constant responsibility for the needs
of others, of easing tired feet and the pleasures of gossip.
Is the worn shape of the housewife
left in her house like a shell?

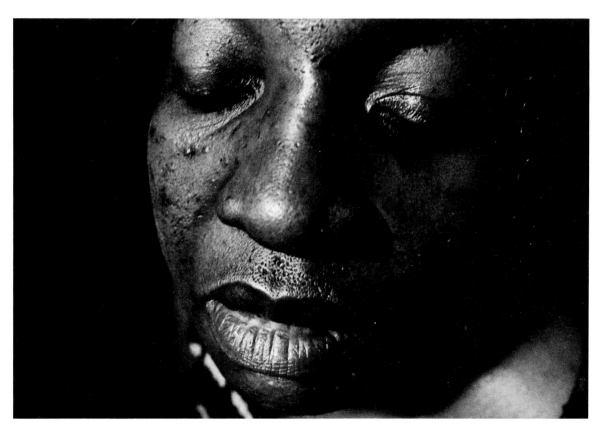

Lenore Davis

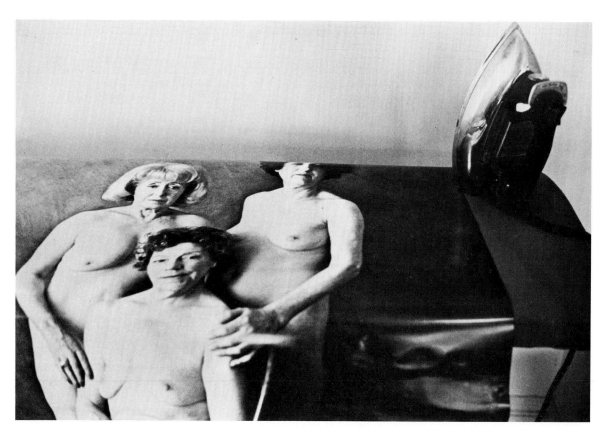

Sherrie Rabinowitz

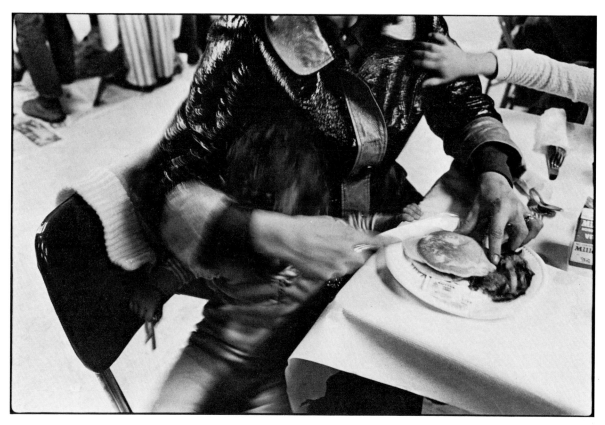

Roz Gerstein

43

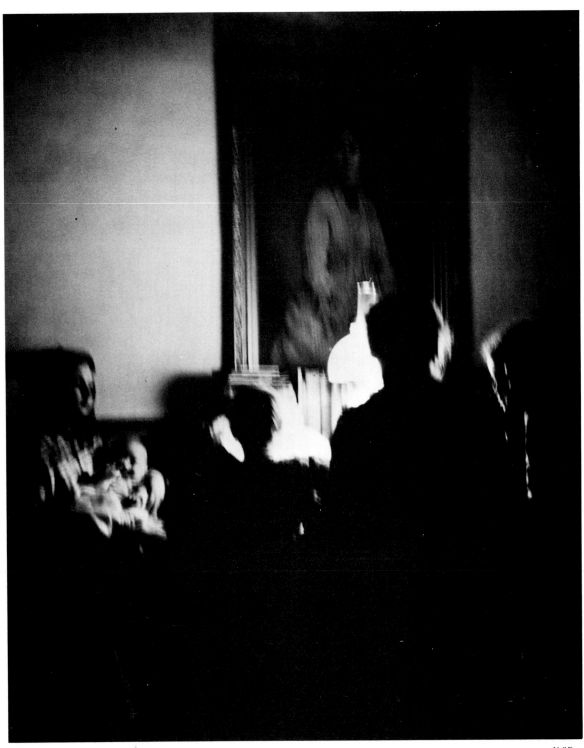

Nell Dorr

44

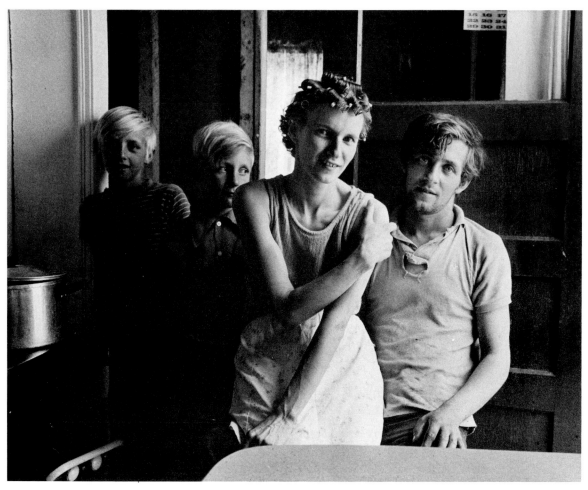

Pamela Harris

45

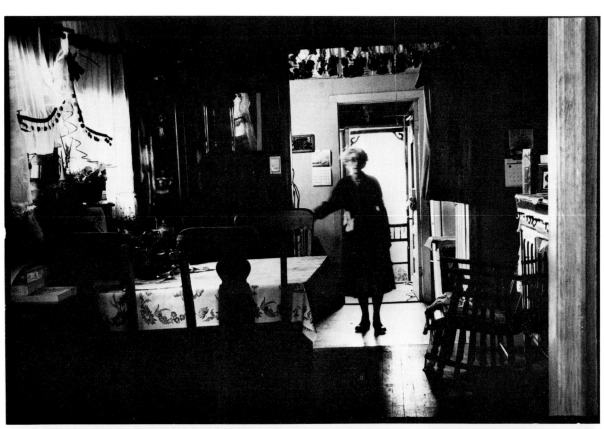

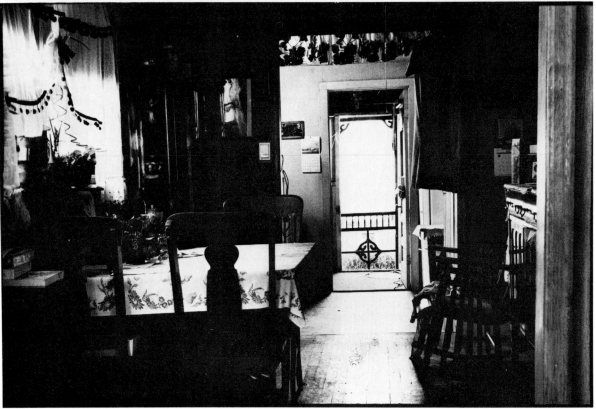

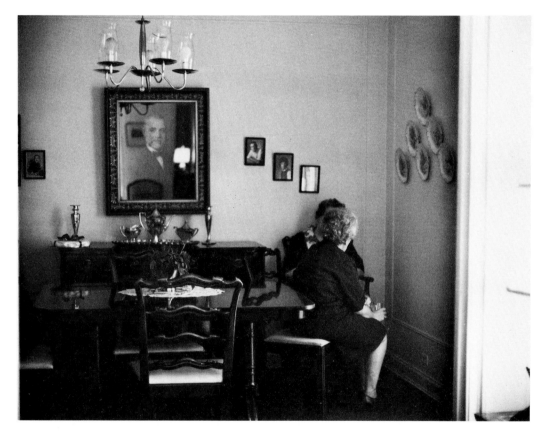

Ellen Galinsky

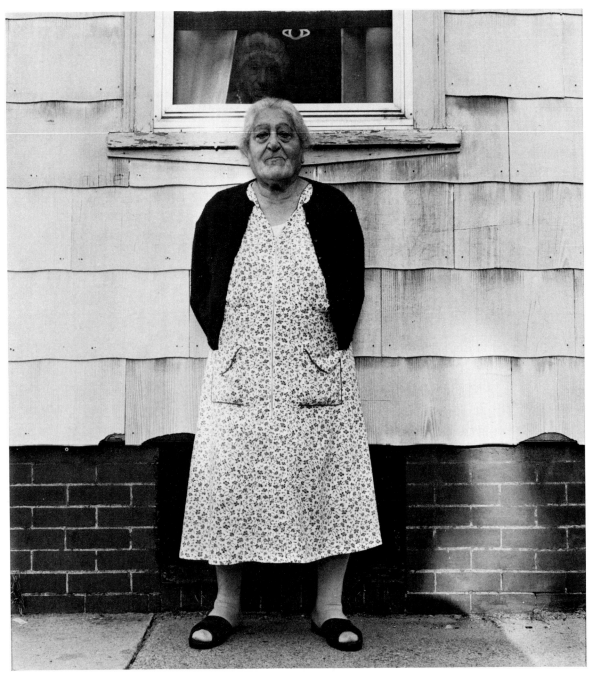

M. K. Simqu

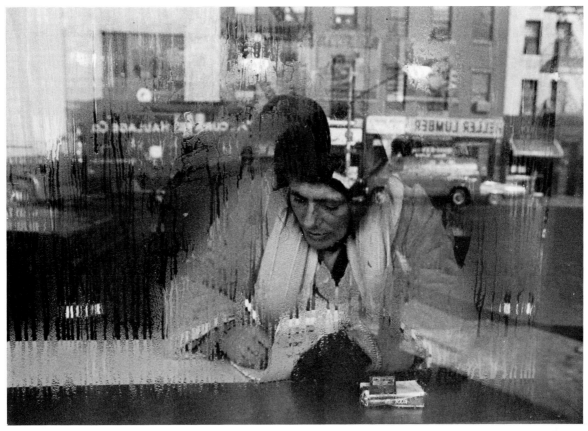

Flo Fox

49

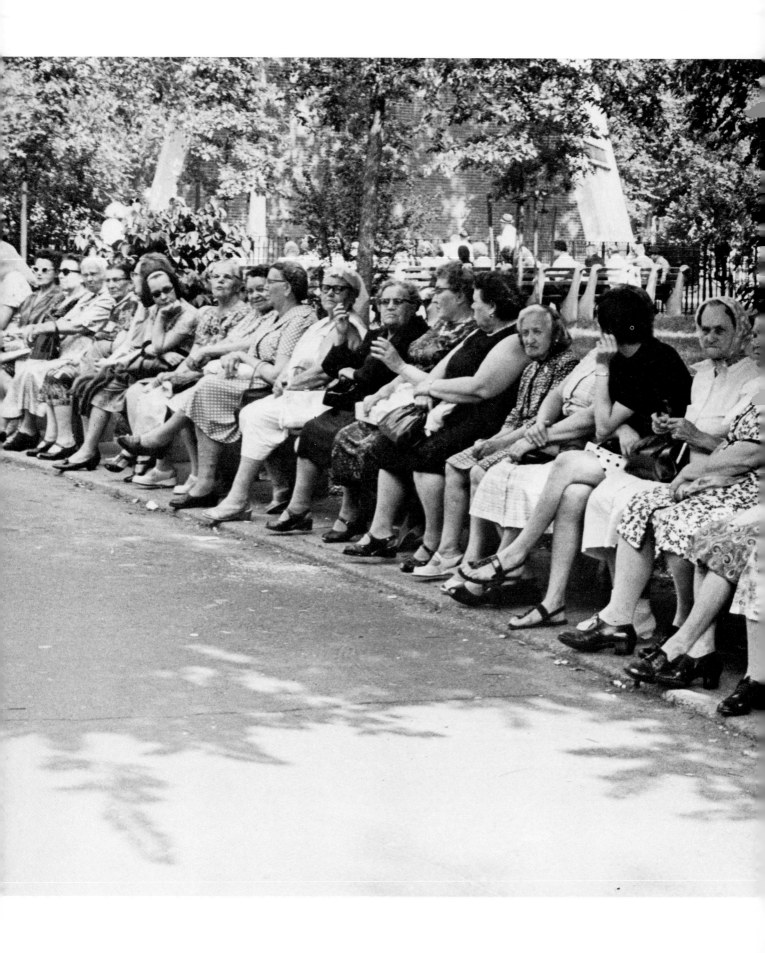

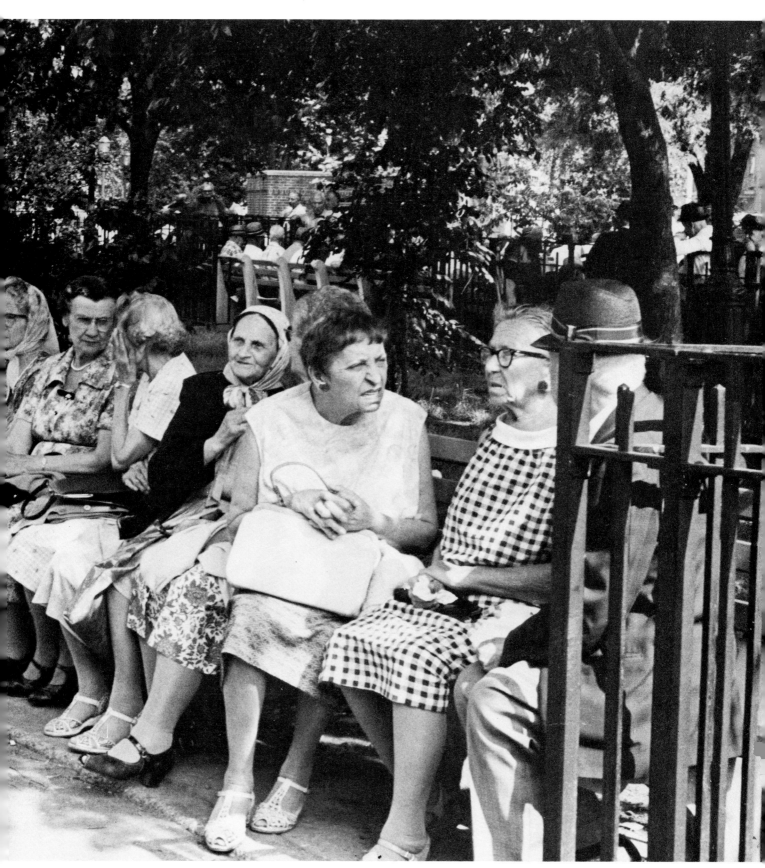

Anna Kaufman Moon

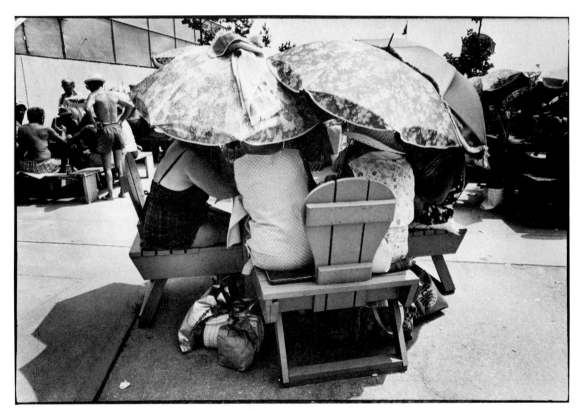

Joan Liftin

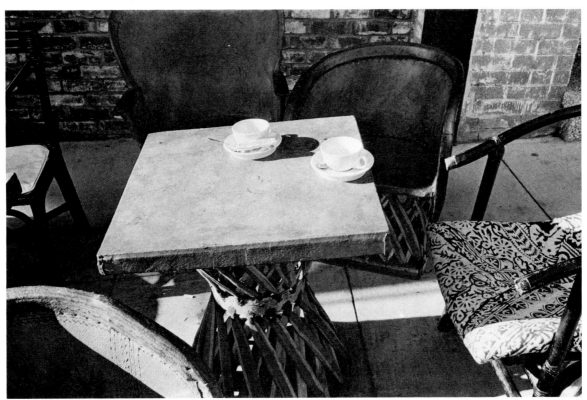

Elaine Mayes

The hands know their own stubborn, humble worth.
They have sustained the world: nourishing, crafting,
digging, pulling, planting. They are poised
on the brink of speech. They have much to tell.

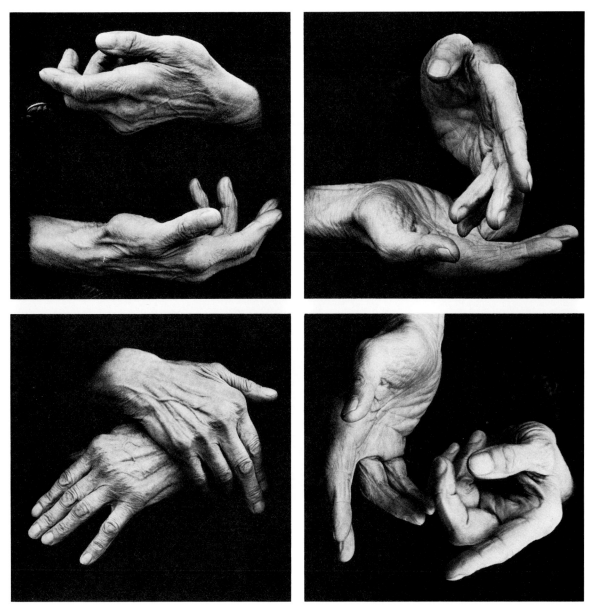

Hanna W. Schreiber

55

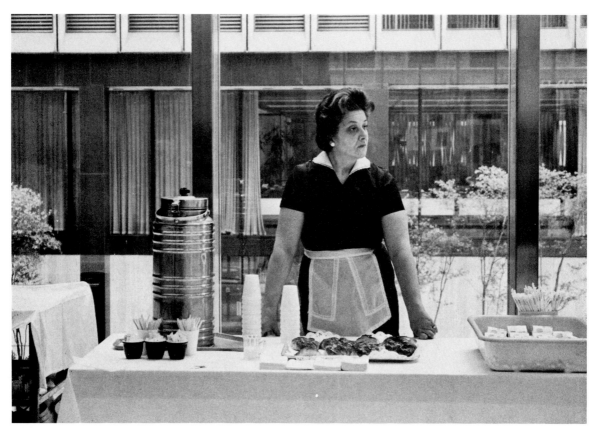

Hélène Gaillet

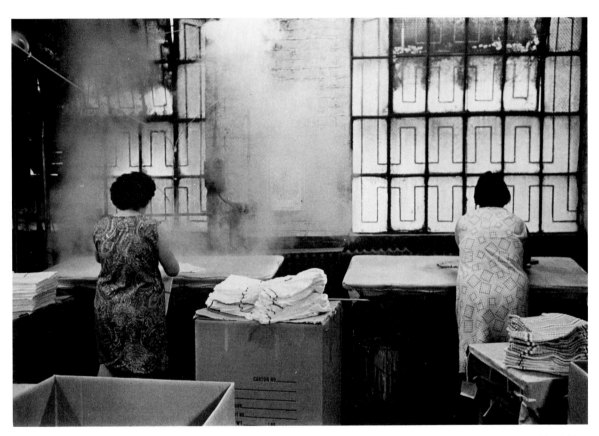

Pamela Harris

57

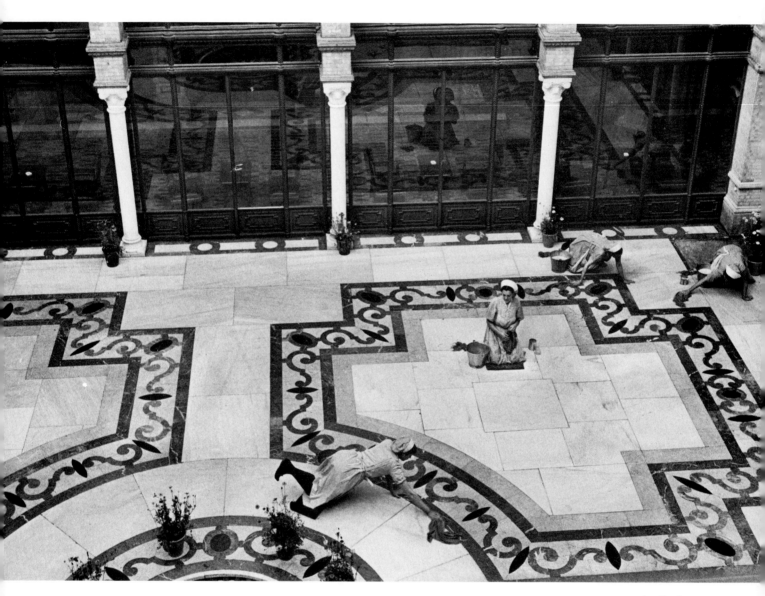

Inge Morath

58

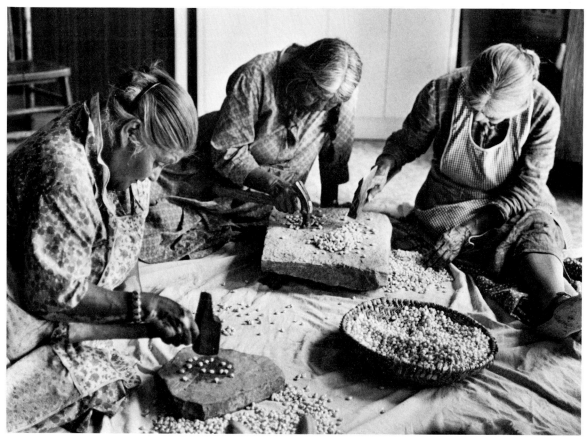

Ulli Steltzer

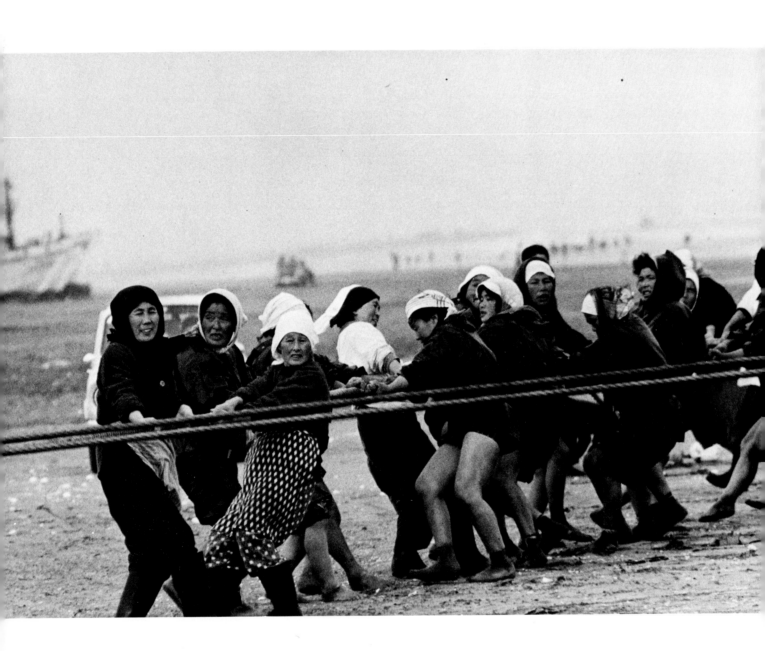

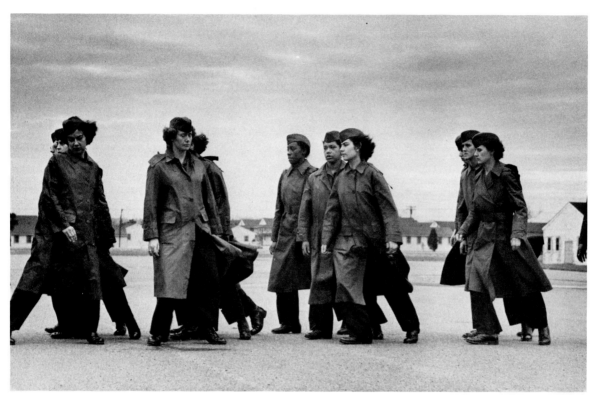

Ruth Orkin

◄ Chie Nishio

61

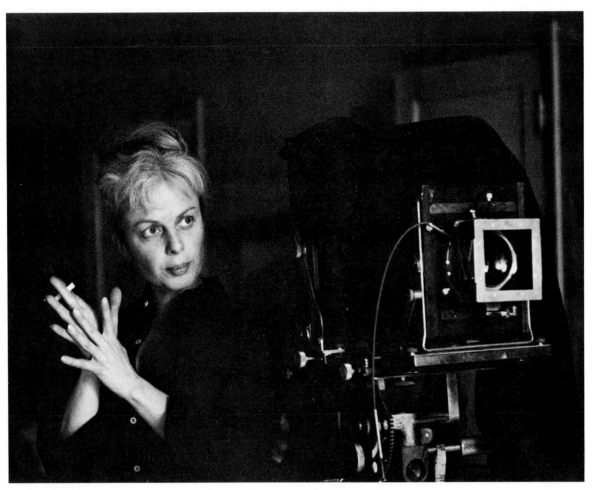

Kay Harris

62

There is such wonder, such joy,
such rage in the first stirrings of power.

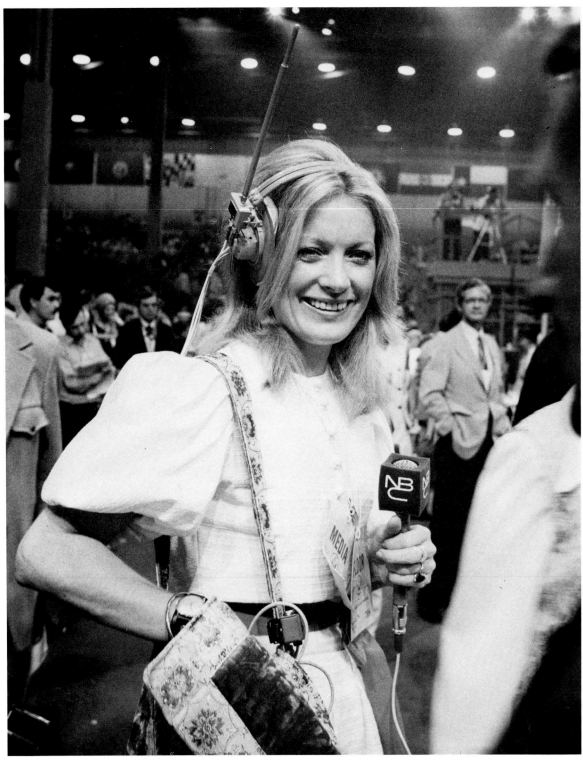

Jill Krementz

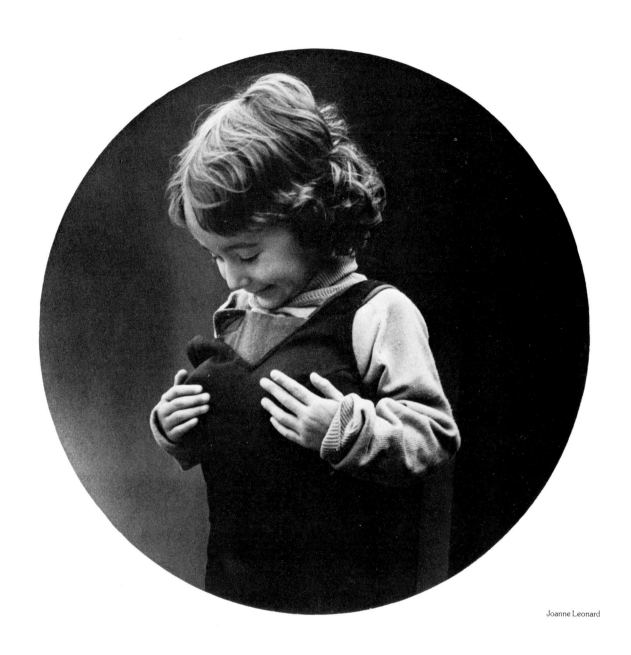

Joanne Leonard

65

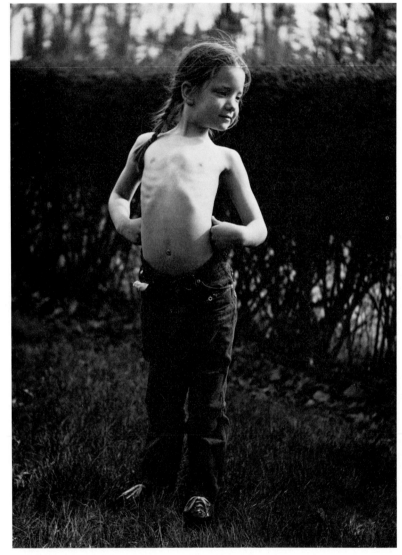

Marjorie Pickens

Wendi Lombardi ▶

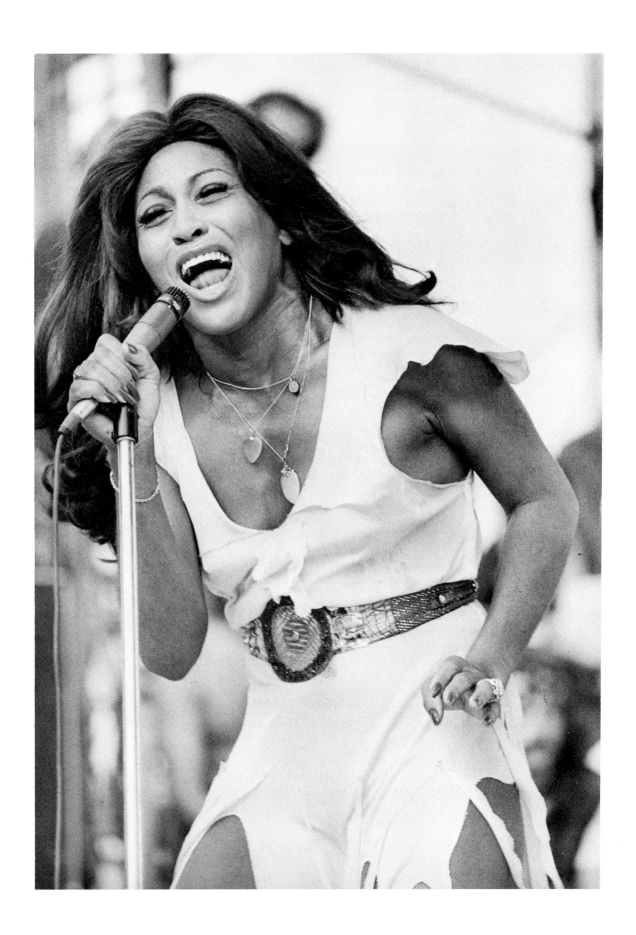

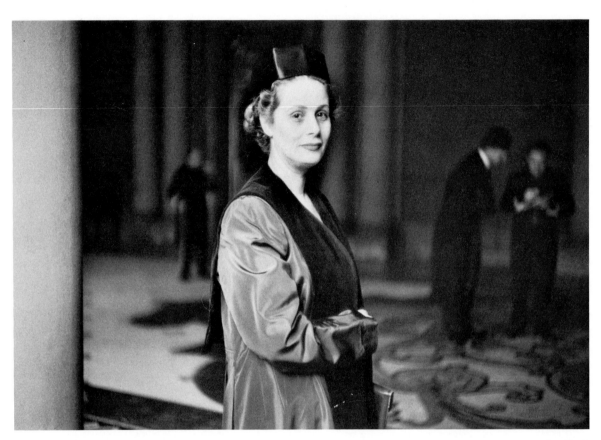

Inge Morath

68

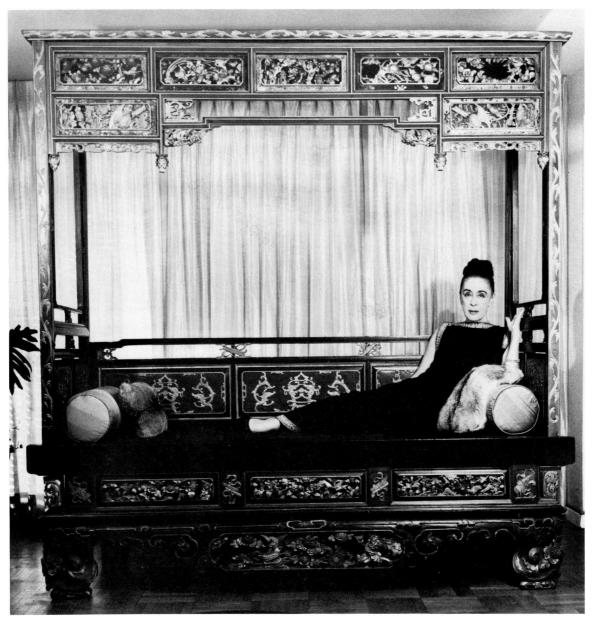

Martha Swope

69

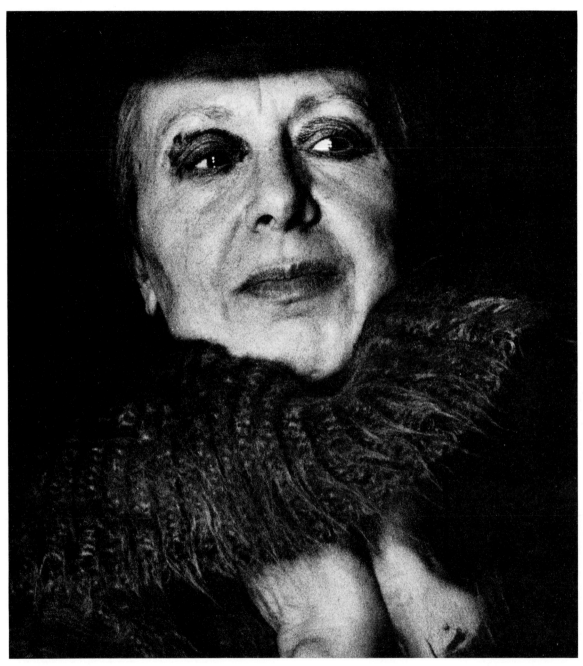

Dena

70

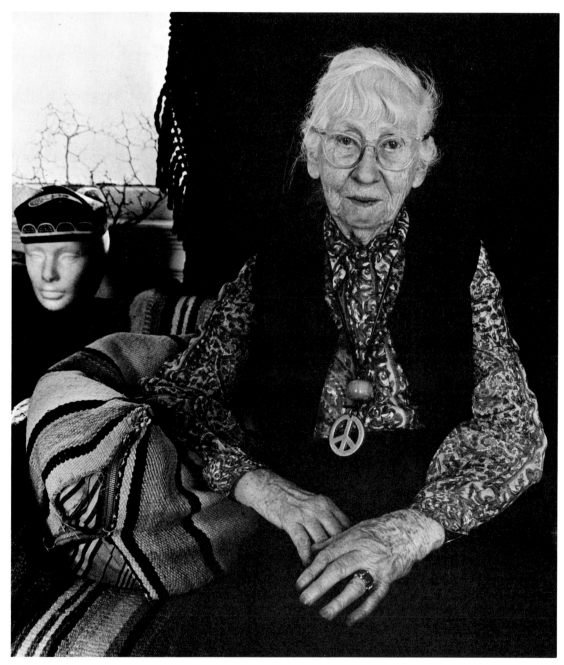

Linda Boyd

71

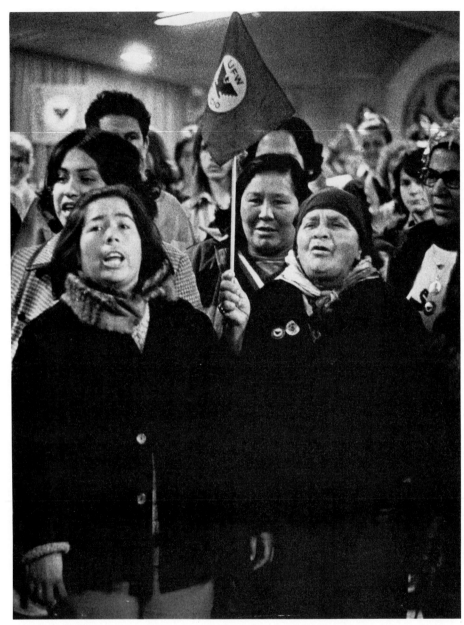

Diana Davies

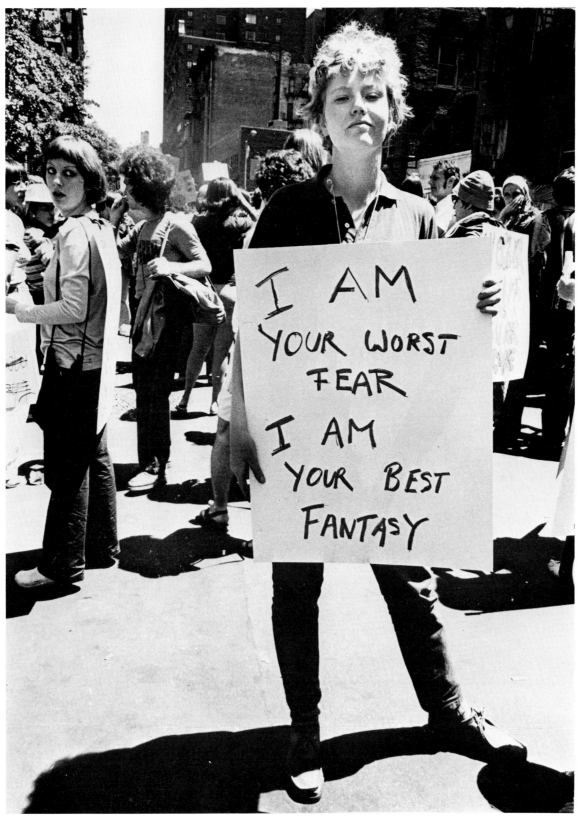

Diana Davies

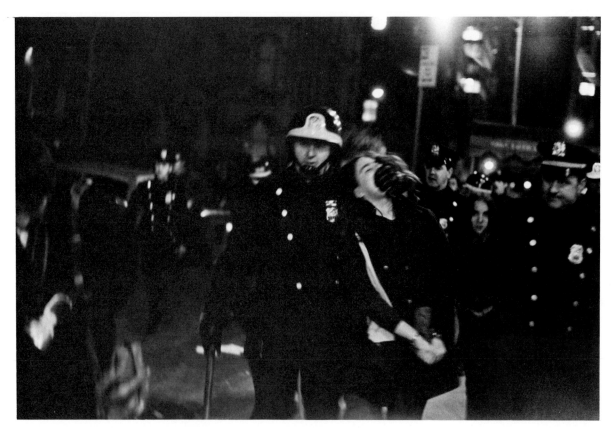

Catherine Ursillo

74

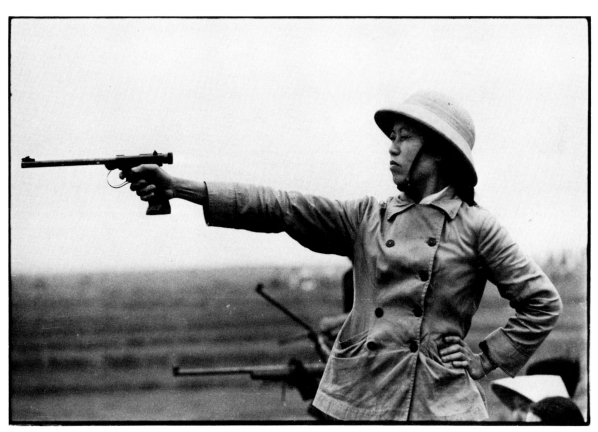

Anne Dockery

75

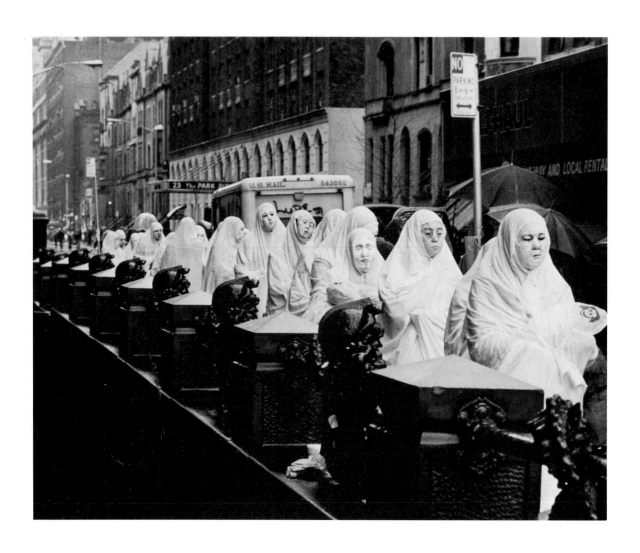

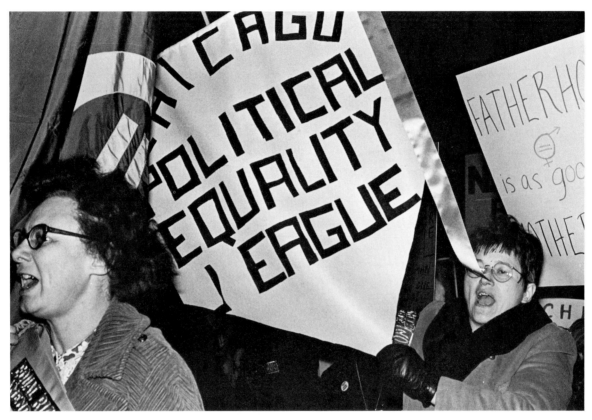

Dorothea Jacobson

For us, the sensual and the human are not far apart,
nor body and soul separate. We see
and touch the spirit in the flesh.

Lynn Adler ▶

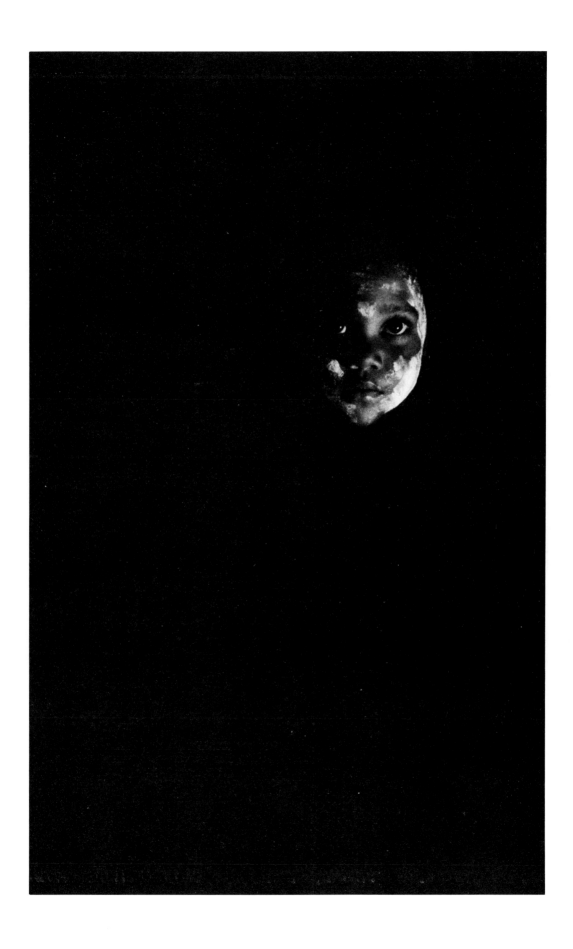

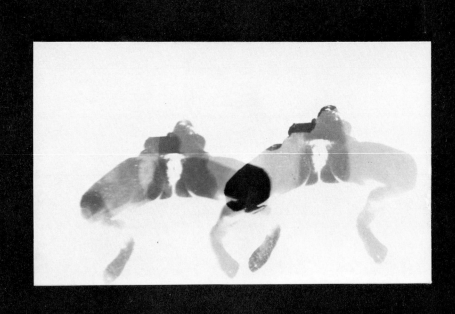

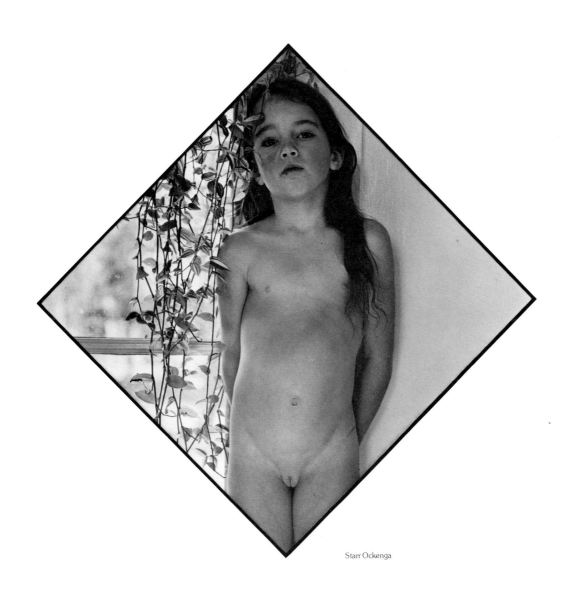

Starr Ockenga

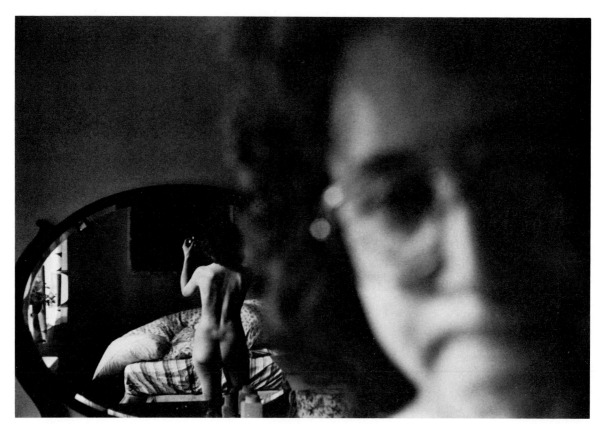

Eileen Friedenreich

Naomi Savage ►

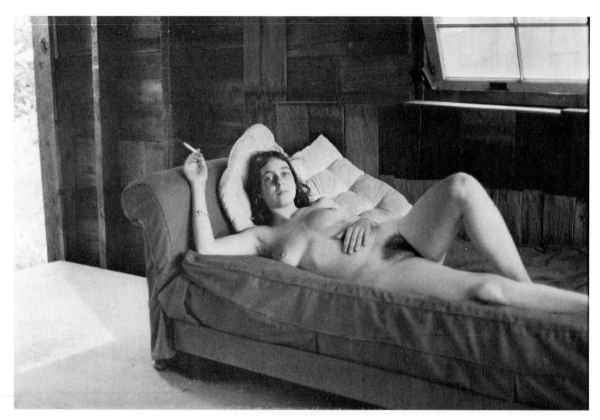

Susan Tinkelman

84

Marcelina Martin

85

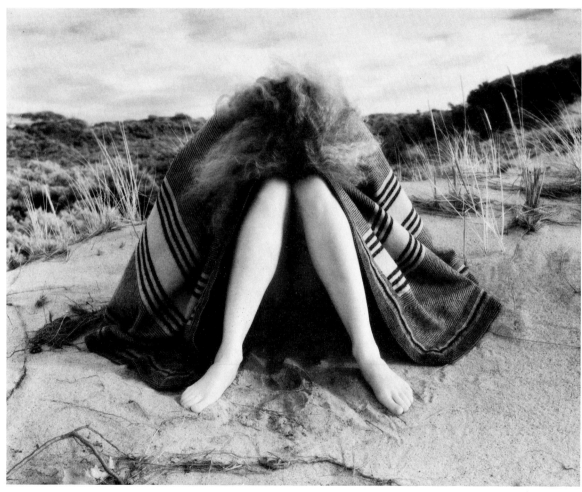

Debora Hunter

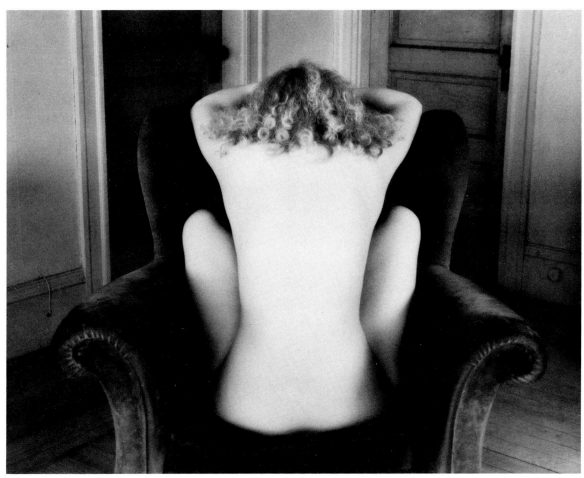

Debora Hunter

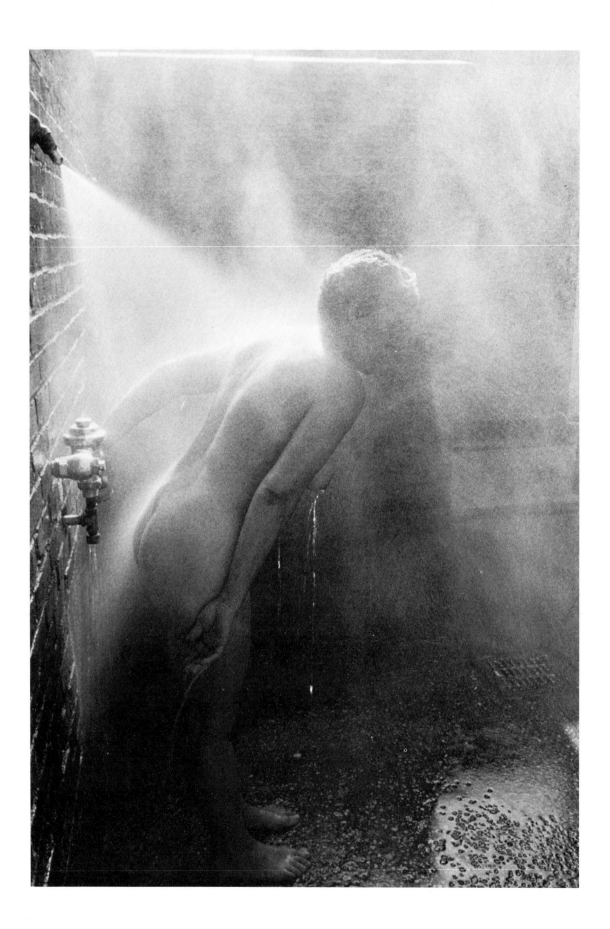

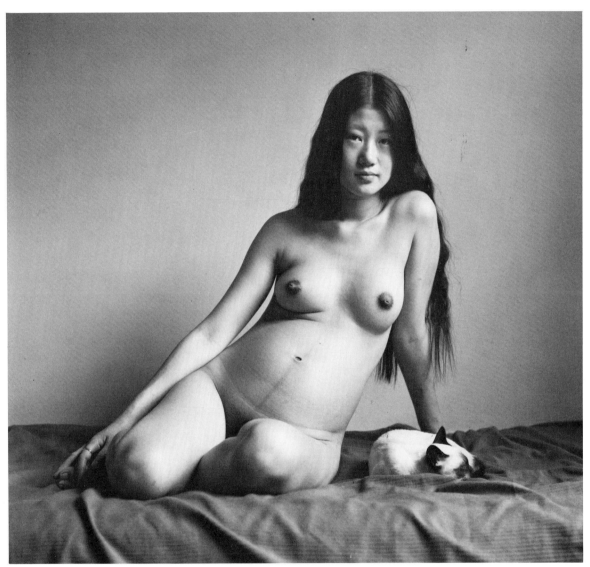

Eva Rubinstein

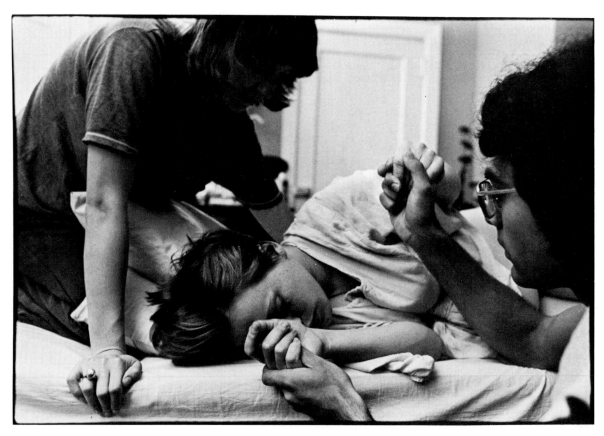

Laura Jones

90

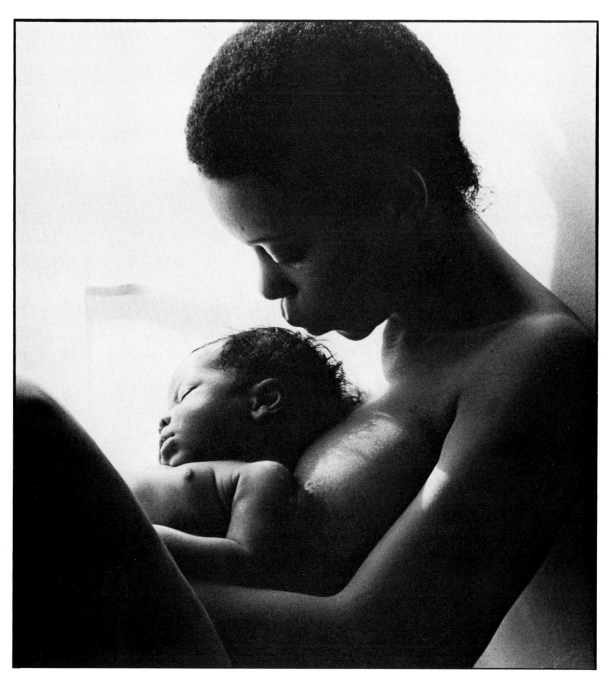

Barbara Jaffee

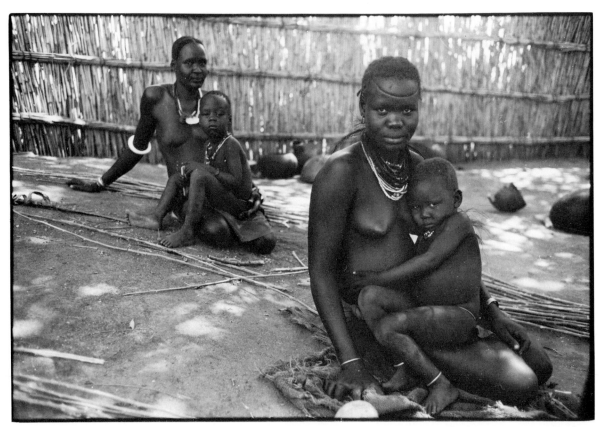

Ming Smith

92

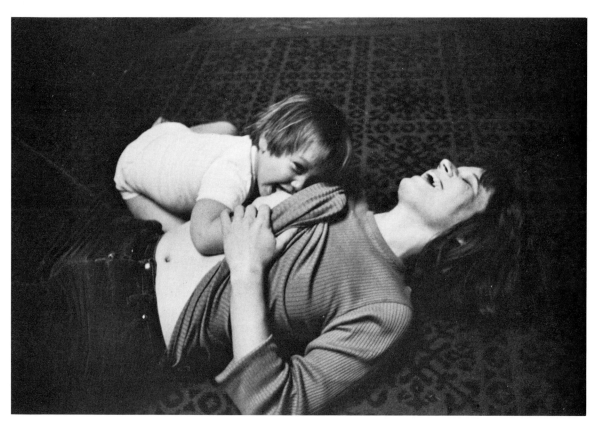

Gretchen Berg

93

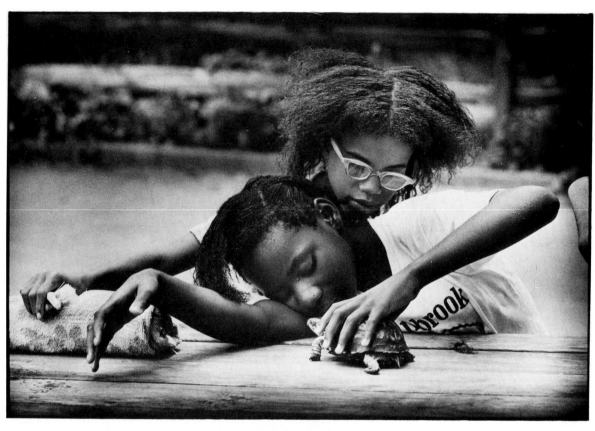

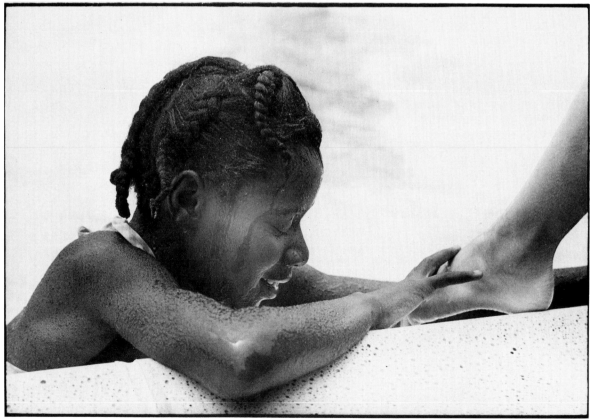

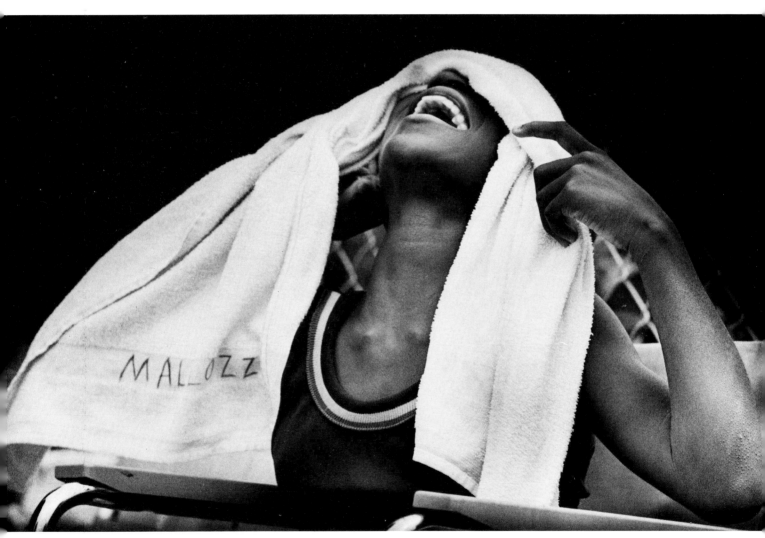

Jodi Cobb

◄ Jodi Cobb

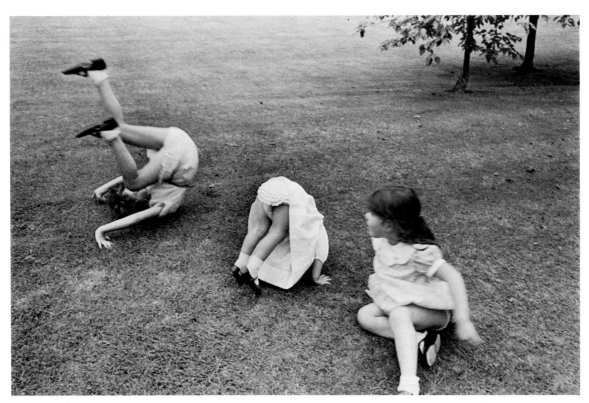

Dena

96

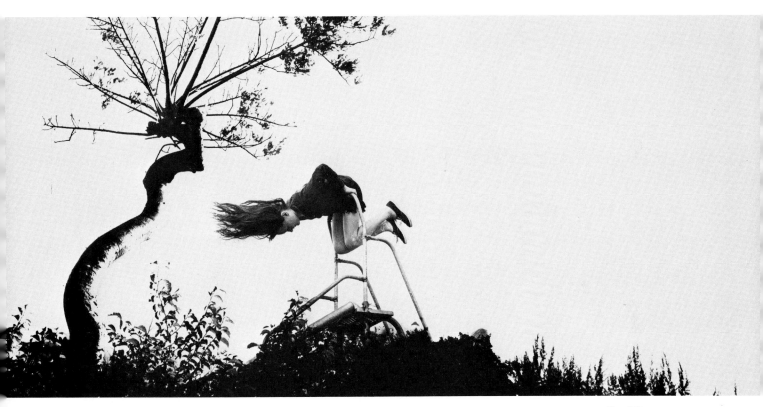

Eileen K. Berger

97

The quaint word fidelity can also mean
a quality of listening. Our best loves — for ourselves,
our sisters, families, husbands — have this
attentiveness, this attunement:
open, curious, humorous, enduring.

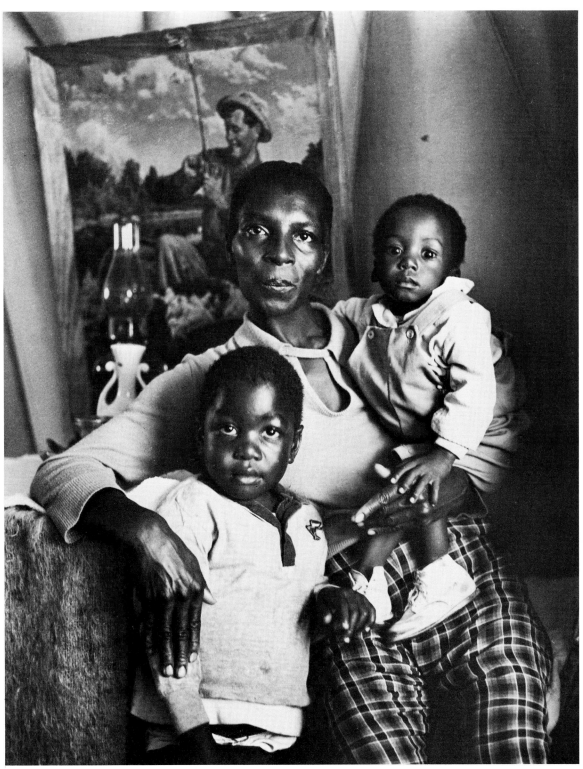

Clara Spain

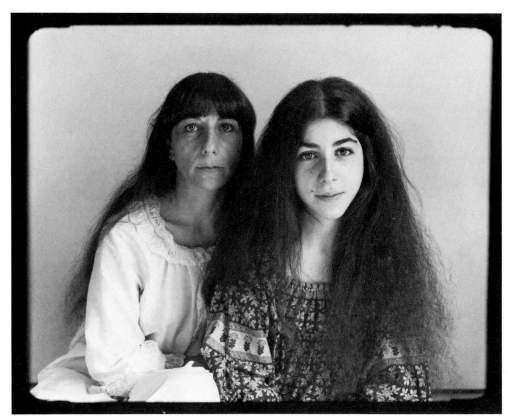

Wendy Snyder Macneil

100

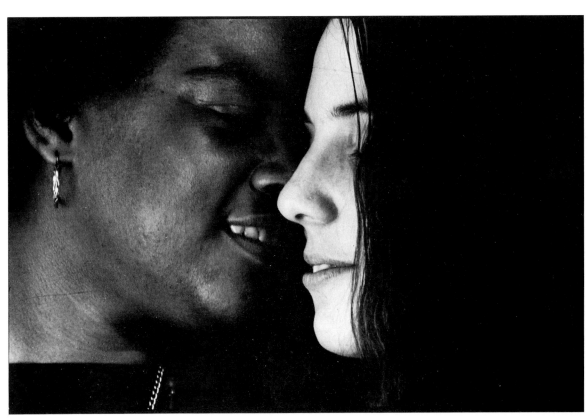

Libby Friedman

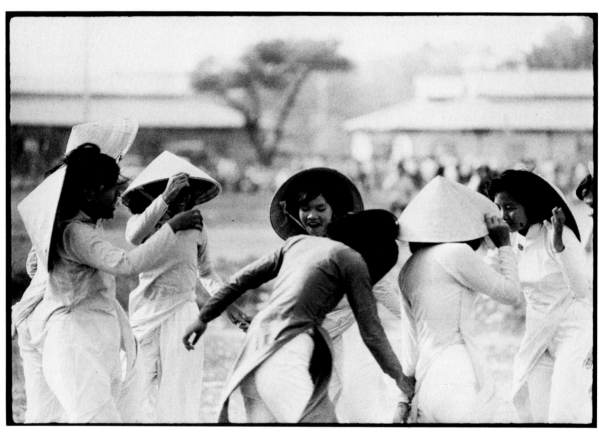

Jill Krementz

102

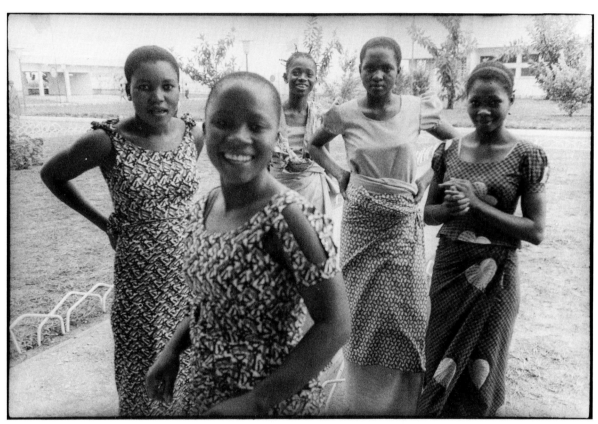

Sonia Katchian

103

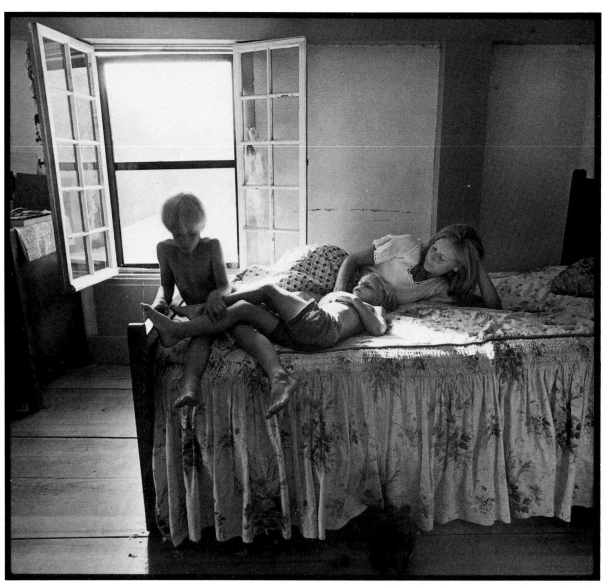

Starr Ockenga

104

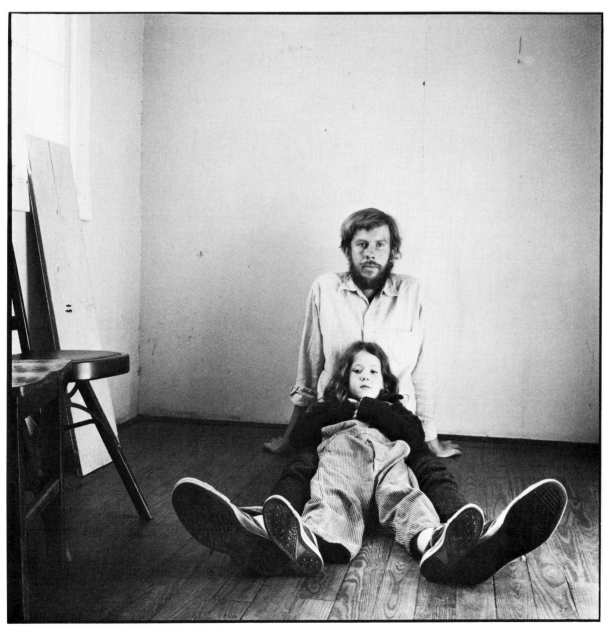

Dolores DiCamillo

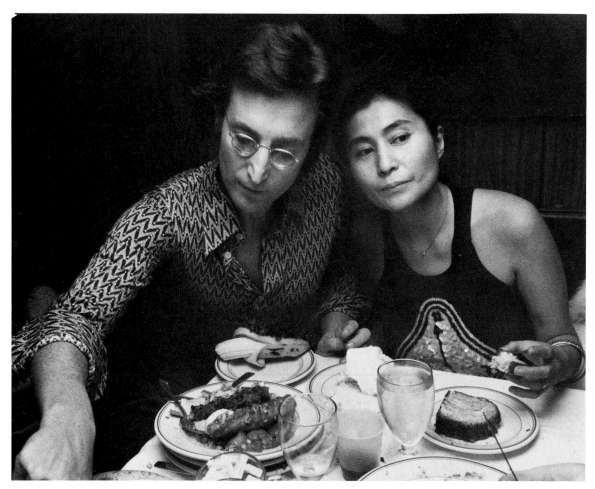

Nancy Crampton

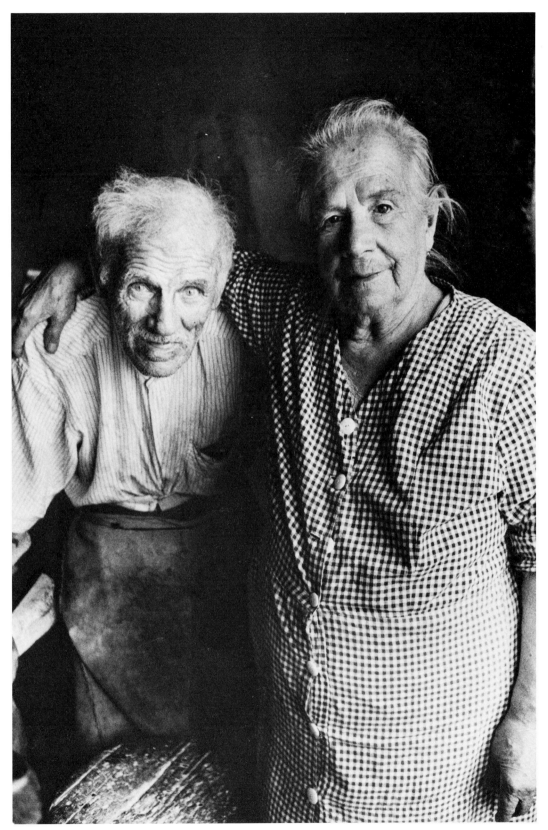

Ellen A. Spitz

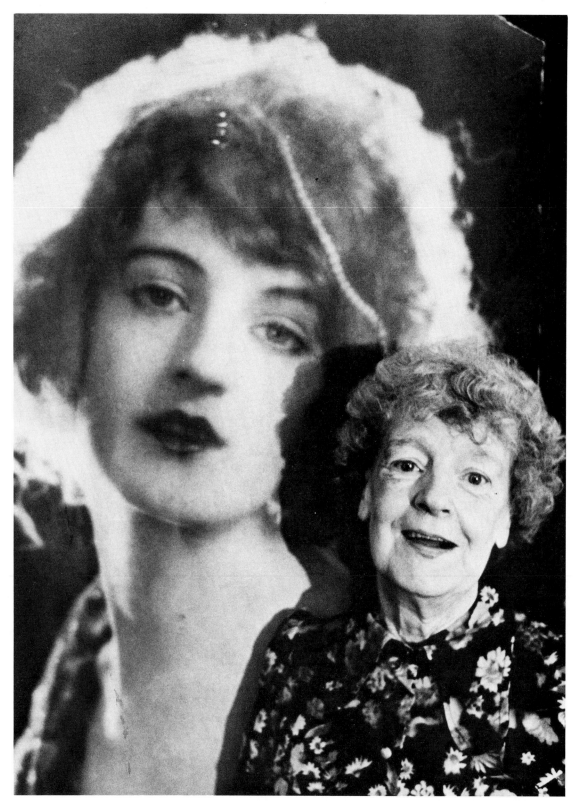

Marcia Keegan

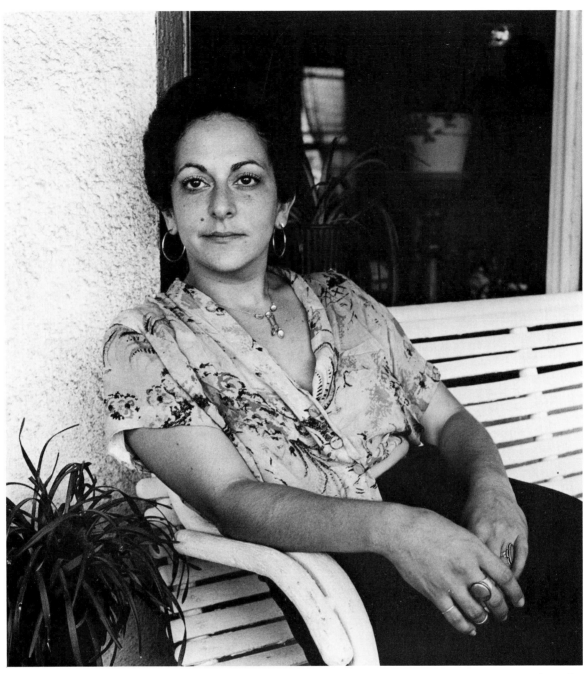

Suzanne Paul

109

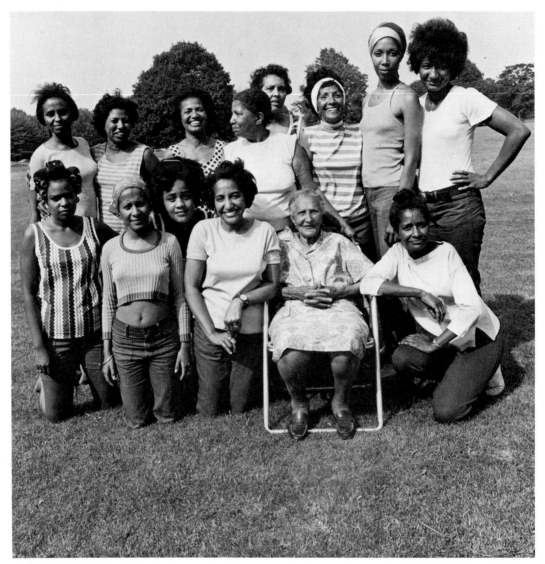

Lauren R. Shaw

110

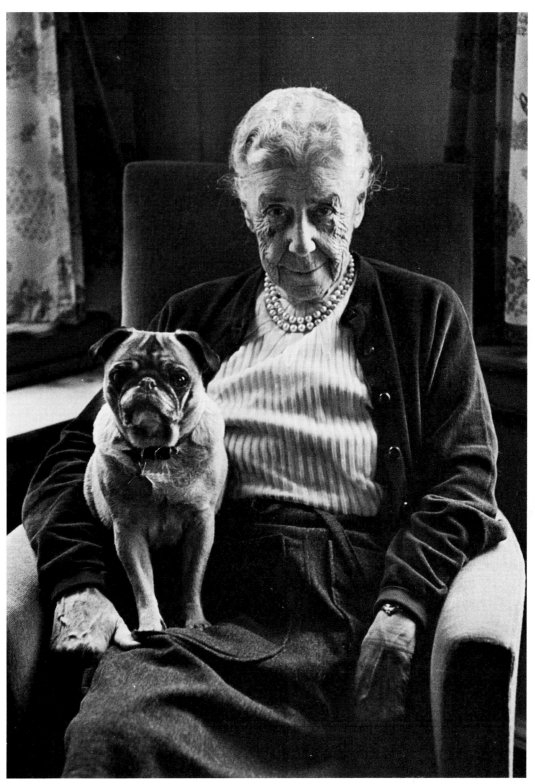

Nancy Sirkis

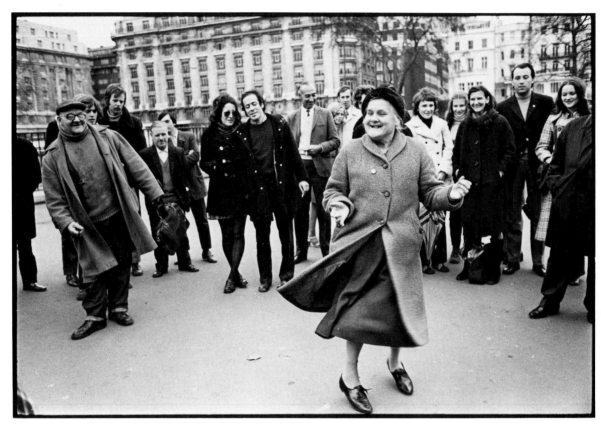

Sardi Klein

112

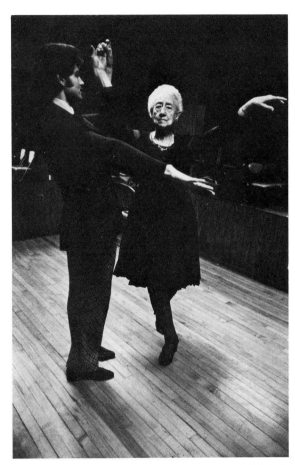

Phyllis Galembo

113

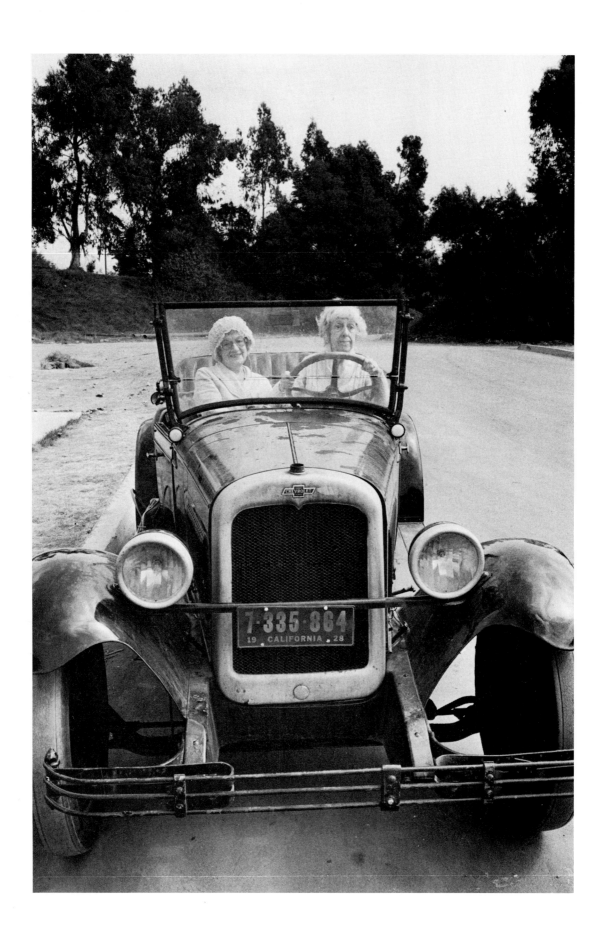

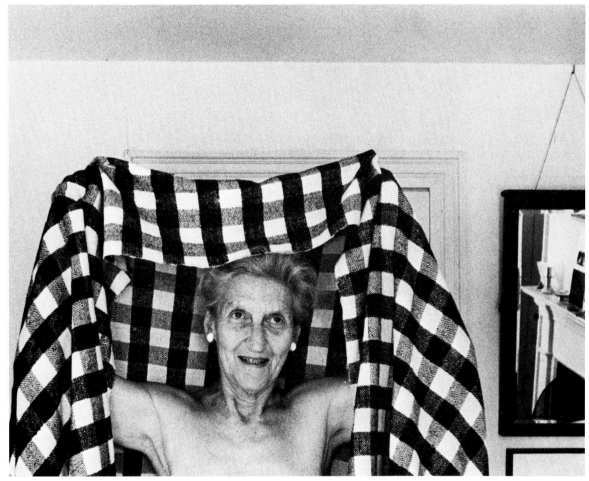

Nina Howell Starr

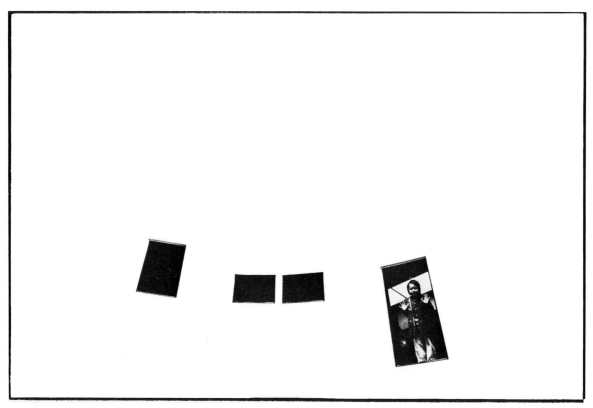

K. A. Milek

Betty Jane Knock ▶

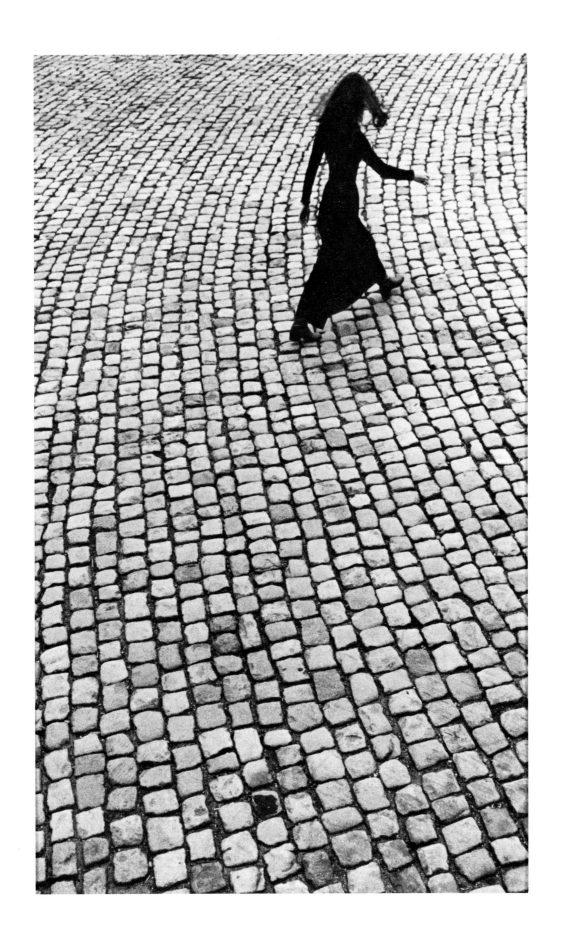

My form does not know the limitation of my name.
My face is one face of the world.

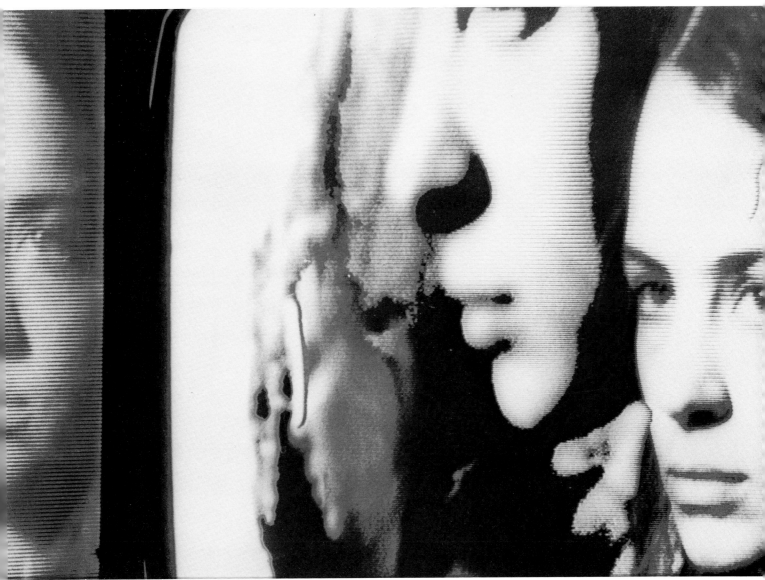

Marcelina Martin

119

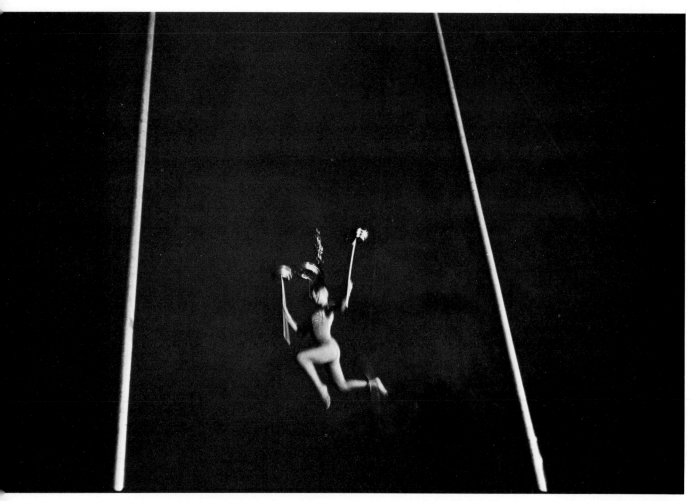

Roz Gerstein

120

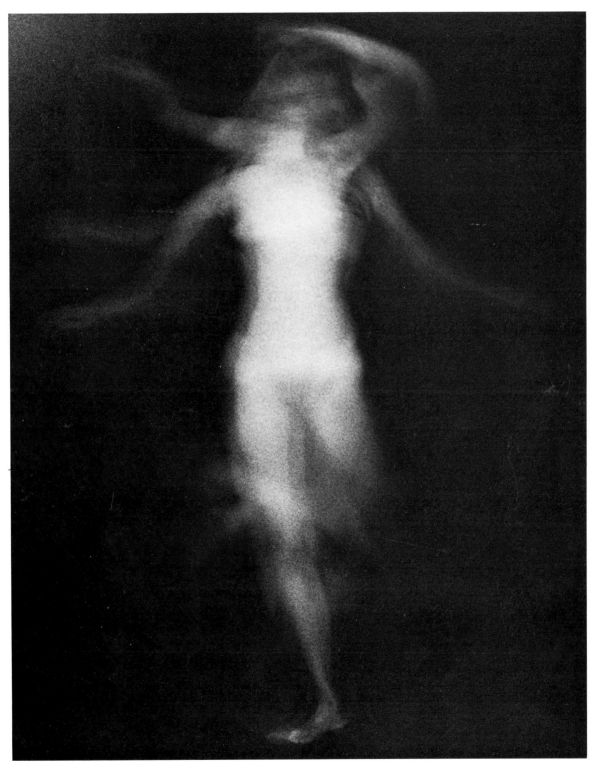

Marsha bailey

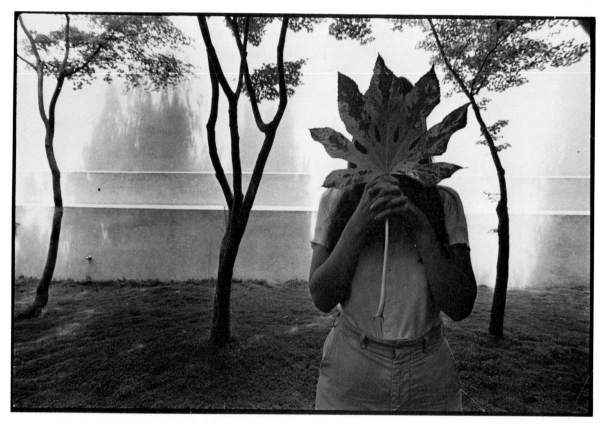

Karen Truax

122

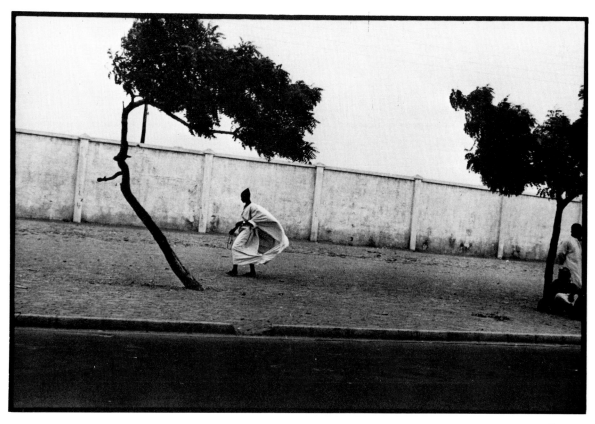

Ming Smith

123

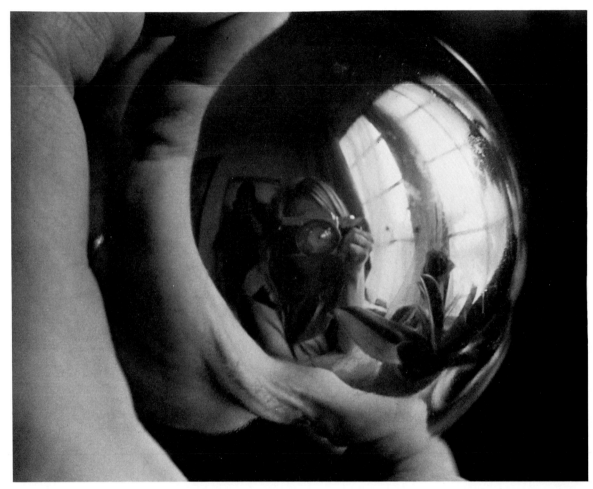

Jan Tieken

124

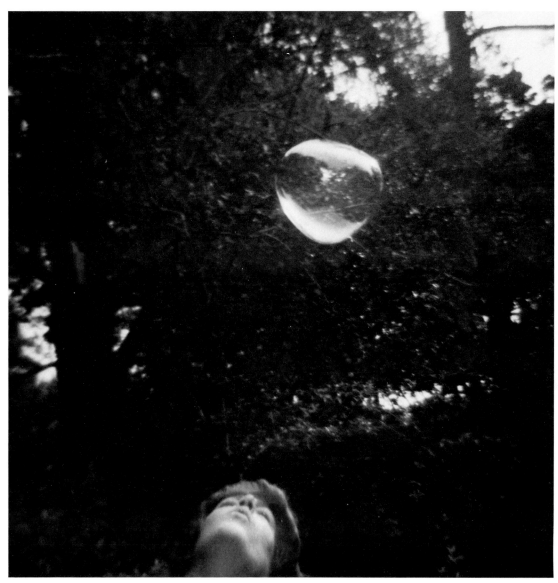

Bea Nettles

125

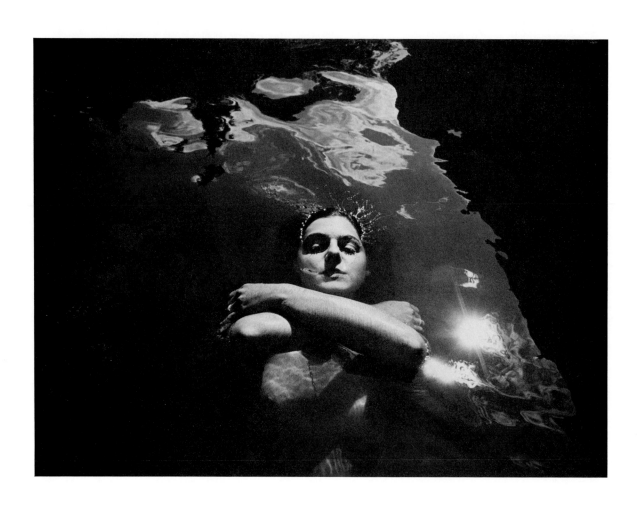

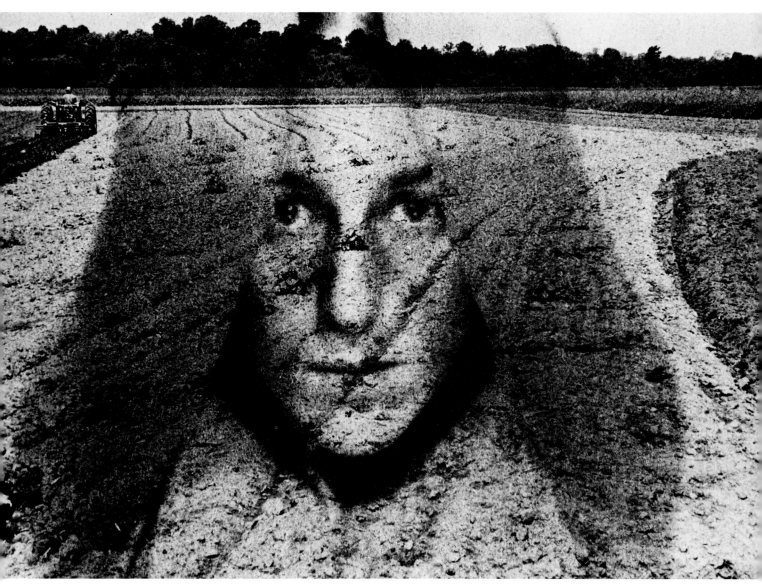

Bobbi Carrey

Hidden within the troubles and joys of the personal is
the core of pure energy, pure life.
It is this that consumes us, becomes us,
in the fire of the dance.

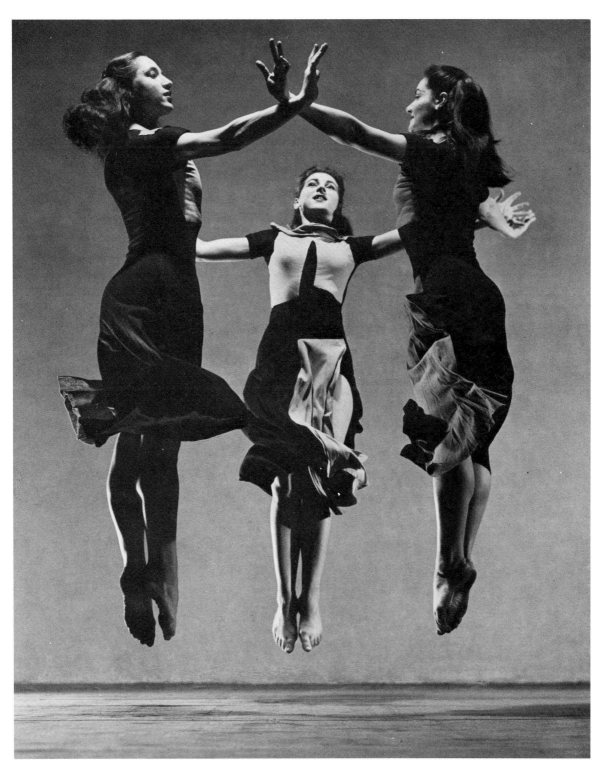

Barbara Morgan

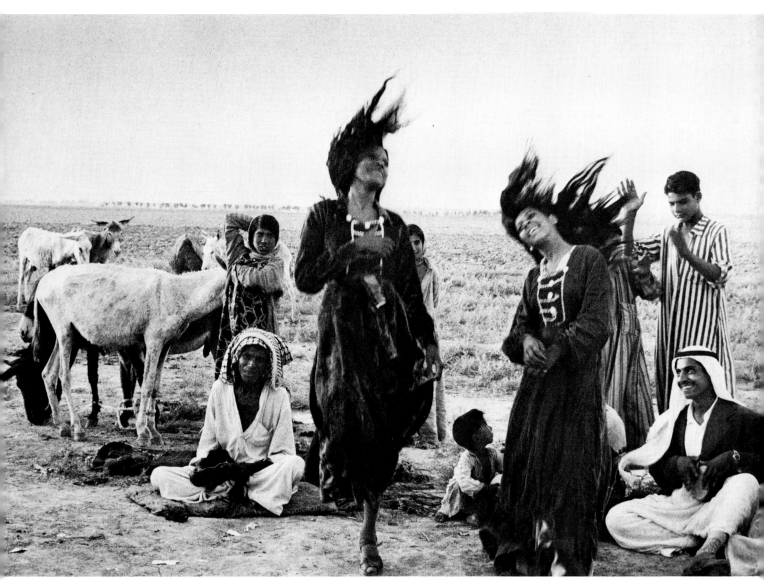

Inge Morath

131

Barbara Morgan ▶

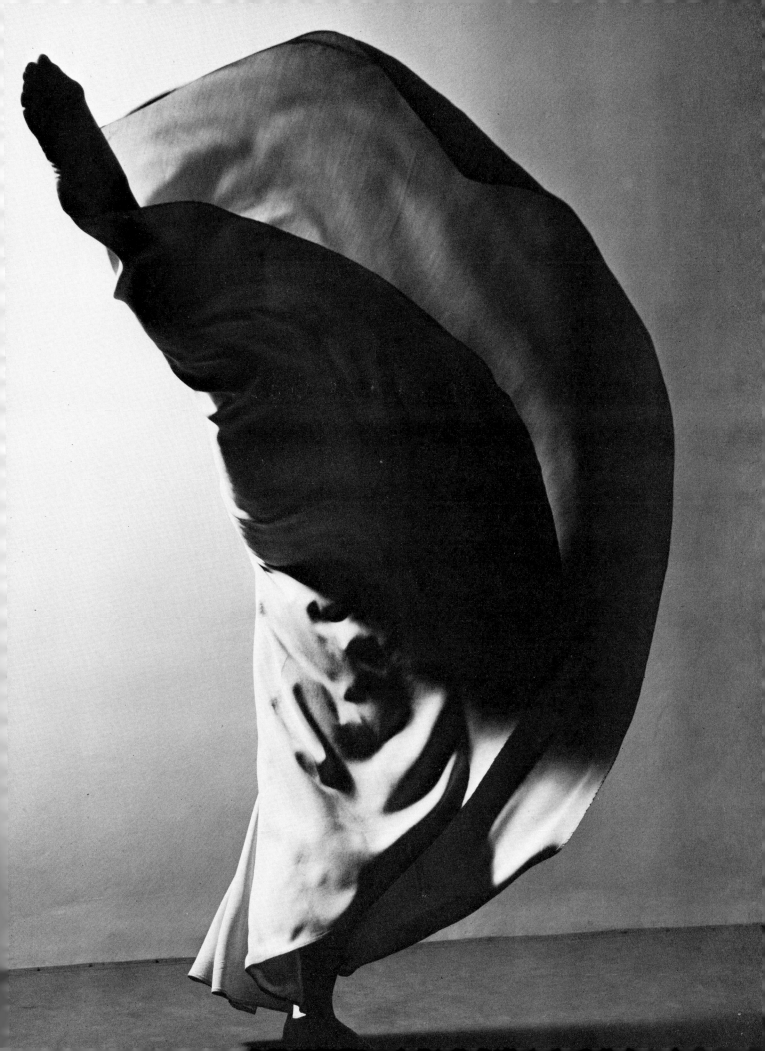

"We've got to get ourselves
back to the garden." Not paradise,
but a new beginning. A celebration of possibility.

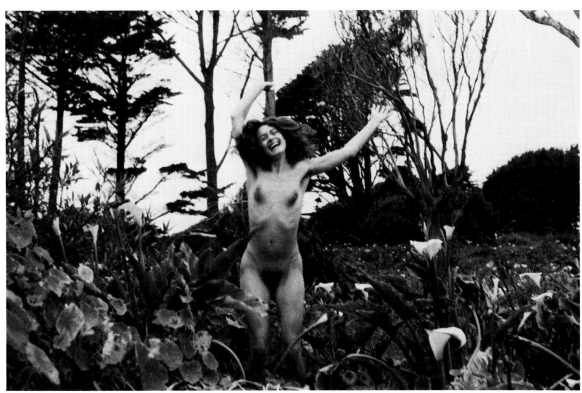

Chris Enos

135

Afterword

Women See Woman *began in the summer of 1973 as a publication project devoted to showcasing work by women photographers. Originally we had planned to compile a general anthology from the work we received. But as the photographs arrived and we started editing, we saw certain recurring themes.*

All in all, we have submitted these pictures to some 50 editing sessions from the first screening to the final refining process that evolved into this collection. Strangely enough, it was only after we had arrived at the "final" selection that we began to group the pictures into some running order. Throughout the project, we edited solely on the basis of artistic merit and communicative content. We had faith that if the photographs met these criteria, they would hold up when assembled in book form.

In one sense, the project has been a special kind of consciousness-raising for each of us—although that was not what we had in mind when we first began. As we gradually became more involved, we discovered that, in a very real way, we were exploring and redefining our own identities. Of diverse backgrounds, professional experience, and age (twenty-five to forty-four), we have each contributed not only to this entity but to each other's as well. Although fiercely individualistic, we have learned to collaborate truly, gaining a deeper respect for ourselves and for each other in the process. And perhaps, in the most personal sense, that may represent our finest achievement.

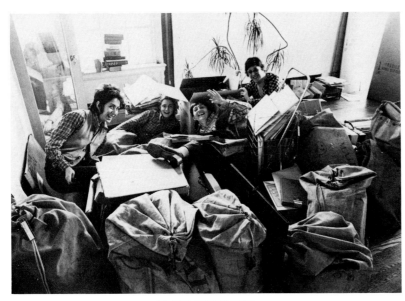

THE EDITORS

Acknowledgments

During the course of this project many people were generous in their support and assistance. We would especially like to thank Donal Holway, Ginger Barber, Sheila LaLima, Mrs. Azad Katchian and Anahid, Owen Epstein, M. W. Merlin, Ruth and Benjamin Grund, Jay Acton, Judith Woracek, Diane Radycki, and Judy Stark. Grateful acknowledgment is also made to the hundreds of women photographers whose enthusiasm and trust made this book possible.

Photographers' Biographies

LYNN ADLER (page 79) is a documentary photographer and a member of the photo-video collective, Optic Nerve. She is currently working on a video-tape dealing with abortion.

SUSAN ANGUS (page 3) is a fund-raising consultant for the Interchurch Center in New York as well as a free-lance photographer. She has taught photography and silk-screen for several years at the Print Shop, a fine arts program for the Lower East Side community.

MARSHA BAILEY (page 121) is a free-lance illustrator and designer as well as a member of the art faculties of Orange Coast College and Mira Costa College in California. She has owned and operated the Floating Wall Gallery in Laguna Beach, California, since 1974.

GRETCHEN BERG (page 93) is one of that rare breed known as "native New Yorker." Her photographs have appeared in numerous publications from the *Underground Press* to *Vogue* since 1966. The photograph which represents her here is from an on-going photoessay begun in 1966 on her friend Lyn Crossman.

EILEEN K. BERGER (pages 5 and 97) has taught both dance and photography at Vanderbilt University, Tennessee State University, and Tyler School of Art. Her photographs have been featured in many exhibitions including those at the Museum of Contemporary Crafts in New York, the Philadelphia Museum of Art, and the Philadelphia College of Art.

LINDA BOYD (page 71) works as a free-lance photographer and has taught black-and-white photography since 1966; she is presently a member of the faculty of the College of San Mateo. Her work has been exhibited in group shows throughout the country and is in the collections of the Oakland Museum and the City of Palo Alto Cultural Center.

BOBBI CARREY (page 127) is a member of the faculties of the Visual Studies Department of Harvard University and the Center for Understanding Media at Antioch College. She has conducted photography workshops for the USIA (United States Information Agency), served as photographer for the Boston Museum of Fine Arts, and, in 1974, was assistant to Walker Evans. Her work has appeared in numerous publications and exhibitions and is included in the collections of the Fogg Art Museum and Bibliotheque Nationale of Paris.

JODI COBB (pages 11, 15, 94 and 95) has just turned to free-lance photography after three years' experience as a newspaper photographer for the Wilmington *News-Journal* and the Denver *Post.* The recipient of the National Press Photographers Association award and a Pulitzer Prize nominee in 1974, her work has appeared in major magazines both here and abroad.

LINDA CONNOR (page 14) became interested in photography while still in high school and continued her studies at the Rhode Island School of Design and the Chicago Institute of Design. She has

been a member of the faculty of the San Francisco Art Institute since 1969.

NANCY CRAMPTON (page 106) is a free-lance photographer whose candid portraits often appear in *Time, Newsweek, The New York Times Book Review, The Washington Post, Ms.*, and the foreign press. Her book on the creative artist in America will be published in the fall of 1976.

ALIDA FISH CRONIN (pages 36 and 126) is a free-lance photographer and teacher. Her work has been published in *Camera 35, Ms.*, and various newspapers throughout the country. At present she teaches at the Naples Mill School in New York while doing graduate work at the Rochester Institute of Technology.

DIANA DAVIES (pages 72 and 73) began working in photojournalism in 1963, concentrating especially on folk music and the civil rights and peace movements. Published internationally in major magazines, her assignments to date have taken her across the United States and to Mexico, Israel, Portugal, Cuba, and Biafra.

LENORE DAVIS (page 41) is a photography instructor at Livingston College of Rutgers University. Her photographs have appeared in magazines both here and abroad, as well as in various exhibitions in the New York area.

DENA (pages 70 and 96) teaches photography at the School of Visual Arts in New York. Originally from Finland, she has lived in the United States since 1947. A free-lance photographer, her work has appeared in many exhibitions and publications and is represented in the collections of a number of museums.

LISL DENIS (page 12) was hired as the first female staff photographer on the Boston *Globe* when she was twenty-one. She has done travel features with her journalist husband for such magazines as *Holiday, Cosmopolitan, Saturday Review, Newsweek, House Beautiful*, and *Glamour*. Her first book, on the history of the windmill, is scheduled for publication in the near future.

DOLORES DiCAMILLO (page 105) began photographing in 1971. After a year of teaching photography at the Harmony Free School in Indiana, she embarked on independent field work throughout West Virginia. At present, Ms. DiCamillo combines work at the Indiana University Library and free-lance photographic assignments.

ANNE DOCKERY (page 75) is a free-lance photographer working for Liberation News Service. At present she is on assignment in London.

NELL DORR (pages 37 and 44) has been widely published both in the United States and abroad. Her books include *In a Blue Moon, Mother and Child, The Bare Feet*, and *Of Night and Day*.

CHRIS ENOS (page 135) has exhibited her work throughout the United States, Canada, and at the Bibliotheque Nationale in Paris. She is represented in the permanent collections of the San Francisco Museum of Art, the San Francisco Art Institute, and the Fogg Museum of Harvard University.

SHELLEY FARKAS (page 80) is known as a photographer, painter, sculptor, art director, writer, and graphic artist. She has exhibited her work up and down the East Coast, as well as in California, Canada, and Central America.

ELAINE FISHER (page 31) has been a free-lance photographer since 1966. The recipient of a National Endowment for the Arts Fellowship in Photography in 1972, her photographs have been included in many exhibitions, including the Maryland Institute of Art, the Creative Photography Gallery at MIT, the Light Gallery in New York, and the Boston Center for the Arts.

FLO FOX (page 49) has been in photography for three years. Nineteen seventy-five marks her first one-woman exhibit—at the Photographer's Gallery in London, England.

JILL FREEDMAN (pages 16 and 17) was an actress and singer before turning to photography; she has been free-lancing since 1968. Her photographs have been seen in major magazines and exhibitions both in the United States and abroad. Her first book, *Old News: Resurrection City*, was published in 1971; a second, *Circus*, in 1975.

EILEEN FRIEDENREICH (pages 30 and 82) had her first one-woman show in 1973 at the Panopticon Gallery, Boston. She has also participated in several group shows, including "Photo Vision 1972" at the Boston Center for the Arts and "Women: Photographic Insights," a traveling exhibition under the auspices of the Massachusetts Council for the Arts.

140

LIBBY FRIEDMAN (pages 88 and 101) has taught photography at the School of Visual Arts in New York and at Fair Lawn Community School. Her work has been published in various photo magazines and exhibited at the Camera Club of New York, the Oscar Wilde and Midtown galleries (New York City).

HÉLÈNE GAILLET (page 56) has been a professional photographer since 1972. Her work has appeared in many magazines and has been the subject of two one-woman exhibits: at the Walton Center in Newton, Pennsylvania, and the Salon des Refuses in New York.

PHYLLIS GALEMBO (page 113) is presently enrolled as a graduate student at the University of Wisconsin. Her work has been included in several exhibits, including Gallery 853 in Madison, Wisconsin, and the Wisconsin Union.

ELLEN GALINSKY (page 47) is a writer and filmmaker as well as a still photographer. One of the founders of the Bank Street Family Center in New York, she directed a series of filmstrips under a grant from the Ford Foundation. She is presently working on a book of nature photographs and a documentary on the Bank Street Family Center.

ROZ GERSTEIN (pages 43 and 120) is cofounder of the Boston Women's Collective. A free-lance photographer and graphic designer, she is the art director of the Women's Yellow Pages, the first source book for women. She organized "Woman: A Photographic Exhibition," which has circulated since 1972 under a grant from the Massachusetts Council on the Arts, and is presently developing it into a book dealing with male and female photographers' perceptions of women.

SUSAN HACKER (page 18) is currently a member of the faculty of Webster College in St. Louis, teaching photography. Her work has been published in major magazines in America and England, and is included in the permanent collection of the Bibliotheque Nationale in Paris.

VIRGINIA HAMILTON (page 27) is a New York-based free-lance photographer whose work appears in various newspapers and magazines throughout the country. Her photographs have been shown in exhibitions at the Museum of the City of New York and also at New York's Neikrug and Underground galleries.

KAY HARRIS (page 62) is a free-lance photographer currently based in Brazil.

PAMELA HARRIS (pages 7, 45, and 57) has been a free-lance photographer for the past eight years. In 1972 she helped organize the exhibition, "Photographs of Women by Women" and, in 1973, she produced "The Women's Kit," a 25-pound multimedia kit about women for use in high schools and colleges. Her work is in the permanent collections of the National Film Board of Canada, Eastman House, and Mount St. Vincent University in Halifax.

MARTHA HASLANGER (page 9) is currently a Radcliffe Institute Fellow in photography. Her work has appeared in numerous photographic exhibitions and film showings including EXPRMNTL-5 at Knokke-Heist, Belgium.

CLAIRE HENZE (pages 4 and 8) is presently a lecturer in photography at the Immaculate Heart College of Los Angeles, as well as staff photographer for *Womanspace Journal* and a free-lance photographer. Her work has been shown widely throughout California.

SUSAN HOUGHTALING (page 38) is a New York-based photographer whose work has been shown in many exhibitions, including those at the University of Iowa, the University of Ohio, and the Refocus National Photography exhibit.

DEBORA HUNTER (pages 34, 86, and 87) was active in the women's movement during college and has recently turned towards photographing various aspects of feminism. At present, she is a graduate student in photography and working on a master's thesis on women and their sexuality.

DOROTHEA JACOBSON (pages 19 and 77) has been an assistant professor of English and Humanities at Chicago City Colleges and Malcolm X College since 1967. Her photographs have appeared in various publications and exhibitions, including the Museum of Contemporary Art in Chicago, the Dittmar Gallery of Northwestern University, and the Darkroom Gallery in Chicago.

BARBARA JAFFE (page 91) is currently teaching photography at The New School for Social Research in New York. Her work has been included in many exhibitions throughout the United States, the most recent of which was at the Soho Photo Gallery in New York.

LAURA JONES (page 90) founded and directed the Baldwin Street Gallery of Photography from 1969-1974. At present, she teaches at the Ontario College of Art and is co-ordinating a touring symposium, exhibition, and slide show related to women in photography.

SONIA KATCHIAN (page 103) is a news photographer by instinct. She received training in art history at Barnard College and, after a few stints as a professional cook in Wyoming and New York City, she was catapulted into photography by publishing her color photos of the George Wallace shooting in *Life*. She has since worked for *Paris-Match, Stern, Sports Illustrated, Time,* and for the Associated Press in Beirut. Ms. Katchian is one of the editors of WOMEN SEE WOMAN.

MARCIA KEEGAN (page 108) is a free-lance photographer whose work appears regularly in major magazines both in the United States and abroad.

SARDI KLEIN (pages 23 and 112) is currently a free-lance photographer and staff photographer for *Money Source,* a financial publication. Her work also appears in *Communications* and *Retirement Living.*

BETTY JANE KNOCK (page 117) is currently studying English literature at Ohio State University with a view to graduate studies in literature and filmmaking.

JILL KREMENTZ (pages 64 and 102) began her photographic career as a staff photographer for the New York *Herald Tribune.* After two years, she resigned to spend a year in Vietnam taking photographs that were subsequently published in *The Face of South Vietnam.* Her second book, *Sweet Pea: A Black Girl Growing Up in the Rural South,* for which she also wrote the text, was published in 1969.

JOANNE LEONARD (page 65) has been included in numerous photographic exhibitions, including the San Francisco Museum of Art, the Wall Street Gallery, and the San Francisco Art Institute. She is represented in the collections of the American Arts Documentation Centre of the University of Exeter in England, the San Francisco Museum of Art, and the International Museum of Photography of the George Eastman House.

JOAN LIFTIN (page 52) has been photo editor of the United Nation's Children's Fund and assignment photographer for UNICEF for the past seven years. Her work has been shown in many exhibitions, including the Lyman Allyn Museum, the Neikrug Gallery, and the Soho Photo Gallery.

WENDI LOMBARDI (page 67) is a photojournalist whose work appears in monthly magazines and daily journals. She specializes in the rock music field.

HELEN McMULLEN (page 29) has worked as a free-lance photographer for three years. She is currently living in Cambridge, Massachusetts.

WENDY SNYDER MACNEIL (pages 1 and 100) is an assistant professor of art at Wellesley College. She has been the recipient of a Guggenheim Fellowship and a National Endowment for the Arts Grant in photography. Her work has been exhibited throughout the United States, in Canada, and in England.

MARY ELLEN MARK (page 114) has been a photojournalist for the past eight years, covering political and military crises around the world. Her work appears regularly in major magazines, including *Paris-Match, Ms.,* and *Esquire.* She was the subject of a monograph published by Alskog/Thomas Y. Crowell, and has a collection of her photographs, *Passport,* to her credit.

MARCELINA MARTIN (pages 85 and 119) studied photography under John McWilliams at Georgia State University. She is currently working on a collection of images drawn from her experiences in the southern United States.

ELAINE MAYES (page 53) was a free-lance commercial photographer for seven years before turning to teaching. At present she is an associate professor of film and photography at Hampshire College. Her work is featured in the collections of the San Francisco Art Institute, the Museum of Modern Art, the Metropolitan Museum of Art in New York, and the Philadelphia Museum of Art.

K. A. MILEK (page 116) is a free-lance photographer presently based in Montreal.

SUSAN R. MOGUL (page 25) is a staff member of the Feminist Studio Workshop in Los Angeles. Active in various feminist art programs for the past two and a half years, she is now involved with a national

video-letter exchange for women, as well as the creation of feminist billboards and murals.

ANNA KAUFMAN MOON (pages 50-51) is a free-lance photographer whose work appears in most major publications, including *Newsweek, Saturday Review, The New York Times* and *The Christian Science Monitor.* Her photographs have recently been published in *A Time to Seek,* a collection of work by Jewish poets.

HONOR MOORE (page 76) has taken film stills, theater photographs, and portraits of friends—especially women artists—for several years. Her poetry has appeared in *American Review* and the Bantam anthology *We Became New.* Her first play, *Mourning Pictures,* was produced in November 1974 at the Lyceum Theatre in New York.

INGE MORATH (pages 58, 68, and 131) has been a free-lance photojournalist for nearly a quarter of a century. Her work has been published in most major magazines in this country and Europe as well as in books of her work including *Fiesta in Pamplona, Venice Observed* (with Mary McCarthy), *In Russia* (with husband Arthur Miller), and *Bring Forth the Children* (with actor-photographer Yul Brynner). She is currently completing work on three books: one on Connecticut where she makes her home, a monograph retrospective of her work, and *My Sister Life,* illustrating the poems of Boris Pasternak.

BARBARA MORGAN (pages 129 and 133) began photographing seriously in 1935. Her first book, *Martha Graham: Sixteen Dances in Photographs,* published 1941, established her as one of this country's outstanding and innovative photograhers. For many years she has contributed articles and reviews to various publications, including *Aperture, Dance Magazine,* and *Image.* At the age of seventy-five, she continues to photograph and frequently lectures at colleges and independent workshops.

BEA NETTLES (page 125) is an adjunct professor of the Visual Studies Workshop, Rochester, New York. Her work has been exhibited in numerous group and one-woman shows. She is represented in the permanent collections of the George Eastman House, Vassar College, the National Gallery of Canada, and the Metropolitan Museum of Art in New York.

CHIE NISHIO (page 60) covered the Tokyo Olympics for the Associated Press and visited the People's Republic of China for AP in 1967. Her work has appeared in *The New York Times, Ms., Parade, Family Circle, Yomiumi* newspaper and various other Japanese publications.

STARR OCKENGA (pages 81 and 104) is the photo editor and chief photographer for the Lawrence (Massachusetts) *Eagle-Tribune.* Her first book, *Mirror After Mirror,* dealing with the female experience from the vantage point of women between the ages of thirty and fifty, will be published shortly.

SUSAN OPOTOW (page 24) is currently teaching photography at C. W. Post College, New York. Her work has been published both here and abroad and she is the recipient of a grant from Polaroid Corporation to teach photography to public school children.

RUTH ORKIN (page 61) is a free lance photographer, teacher, and feature-film director. Her photographs have appeared in many major magazines and her work is included in the collections of the Metropolitan Museum of Art and the Museum of Modern Art. She co-directed the award-winning films *The Little Fugitive* and *Lovers and Lollipops* and is credited with starting the New Wave in France.

SUZANNE PAUL (pages 35 and 109) has been photographing for the past five years, concentrating mainly on portraits. Her work has been shown in a number of exhibits in San Francisco and in Houston, including three one-woman shows.

DONNA-LEE PHILLIPS (page 33) has worked as a commercial artist, seamstress, children's designer, carnival hand, and typographer in addition to free-lance photography. The recipient of a National Endowment for the Arts Grant, her work has been exhibited both in group and one-woman shows at Pratt Institute, the San Francisco Art Institute Photo Gallery, and the Portland School of Fine Art.

MARJORIE PICKENS (page 66) was born in China and began taking pictures with a Kodak Brownie during her high-school days there. After several years of teaching writing and literature, she became picture editor and researcher for McGraw-Hill and Time-Life Books. Her photography gradually became more vocation than avocation and she is now a free-lance photographer who counts children among her favorite subjects.

143

SHERRIE RABINOWITZ (page 42) is a documentary photographer and a member of the photo-video collective, Optic Nerve. She is currently working on a videotape dealing with abortion. The photograph which represents her here was done with the assistance of Ethel Silvers.

EVA RUBINSTEIN (pages 21, 39, and 89) was born in Argentina of Polish parents and lived in Paris until World War II. A former dancer and actress, Ms. Rubinstein became a free-lance photographer in the late sixties. Her work has been exhibited and published widely and is in the collection of the Metropolitan Museum of Art. A monograph on her work was published early this year.

NAOMI SAVAGE (page 83) is represented in the permanent collections of the Museum of Modern Art, The Fogg Museum, Princeton University, and various private collections. A graduate of Bennington College, she studied photography with Man Ray.

HANNA W. SCHREIBER (page 55) is a free lance photographer whose work has appeared in many textbooks and brochures of various social agencies. A member of Camera Infinity, a photo collective, her work has been shown in many exhibits, including the Emily Lowe Gallery of Hofstra College in New York, the Newark Museum, Rhode Island School of Design, and a group exhibition circulated under the auspices of the New Jersey State Council on the Arts.

LAUREN R. SHAW (pages 20 and 110) is assistant professor of photography at Emerson College in Boston. Her work has been exhibited in many group and one-woman shows, including the Panopticon Gallery, Enjay Gallery, Perception Gallery, and St. Mary's College of Notre Dame.

M.K. SIMQU (page 48) is currently teaching photography at Drexel University.

NANCY SIRKIS (page 111) is a free-lance photographer whose work is on display at Skidmore College and in various private collections. To date, she has produced four photo books: Newport—Pleasures and Palaces (1962), Boston (1964), One Family (1971) and Reflections of 1776—The Colonies Revisited (1974).

MING SMITH (pages 92 and 123) is a young free-lance photographer whose work has appeared in the Black Photographers' Annual, volumes I and II. A member of the Kamoinge workshop, she recently participated in an exhibition at the new International Center of Photography in New York.

SUSAN G. SMITH (page 46) is currently completing graduate studies at California State University. Her work has been shown in several exhibitions, including those at the Riverside (California) Art Center and Pratt Institute in New York.

CLARA SPAIN (page 99) has been taking pictures professionally for approximately fifteen years. Her photographs have appeared frequently in textbooks and magazines, and she is currently combining photography with editorial work for a major book publishing company.

ELLEN A. SPITZ (page 107) is a free-lance writer/photographer and a media specialist for the National Fire Protection Association.

NINA HOWELL STARR (page 115) decided to become a photographer when she was fifty-eight years old. She received her M.F.A. in photography from the University of Florida two years later, in 1963. The photograph which represents her here is a self-portrait.

ULLI STELTZER (page 59) is currently working on a photo book of native British Columbian artists. Born in Germany, she came to the United States in 1953 and operated a small portrait studio in Princeton, New Jersey, for fifteen years before moving to Vancouver. She is represented in the permanent collections of Princeton University.

MARTHA SWOPE (page 69) is noted for her photographs of the New York dance and theatrical world. She is official company photographer for both the New York City Ballet and the American Ballet Theater as well as a free-lance photographer for numerous dramatic productions.

SUZANNE SZASZ (pages 10 and 22) has been a successful free-lance photographer for the past twenty years. Her work has been published in most major magazines as well as in several photo books, including The Silent Miaow. She is currently working on a book about children.

PAT TAVENNER (page 6) is a painter, correspondent artist, and photographer. Her works have been published in major art and photography magazines, included in numerous exhibitions, and are repre-

sented in the permanent collections of the Oakland Museum of Art as well as in private collections.

JAN TIEKEN (page 124) is a dance therapist, actress, and costume designer as well as a photographer. Her work has been shown at the Brockman and Womanspace galleries.

SUSAN TINKELMAN (page 84) is a free-lance photographer specializing in portraiture and fashion photography. She is a member of 20/20, an independent association of women photographers. Her work has been shown in several exhibitions, including the A.C.A. Gallery, the University of Iowa, and the Floating Foundation of Photography.

KAREN TRUAX (page 122) is currently working on an M.F.A. at the University of New Mexico. Her work has been shown in a number of exhibitions at the San Francisco Museum of Art, the Neikrug Gallery, and the Fogg Art Museum; she is represented in the permanent collections of Yale University, the Museum of New Mexico at Santa Fe, and the Albuquerque Art Museum.

ANNE TUCKER (page 13) has worked at the International Museum of Photography in Rochester, New York, and at the Museum of Modern Art (where, as a curatorial intern, she directed the exhibition "Photographs of Women" in 1970). In 1973 she edited *The Woman's Eye*, dealing with the work of ten outstanding women photographers. At present, Ms. Tucker teaches at the Philadelphia College of Art. She has had several one-woman shows of her own work.

CATHERINE URSILLO (page 74) has worked as a free-lance photographer for the past seven years. Her photographs have appeared in most major publications and have been shown at a number of galleries in New York City.

MICHELLE VIGNES (page 32) was born in Reims, France. She came to New York to work with the United Nations Photo Department in the early sixties. Since 1966, Ms. Vignes has been a free-lance photographer specializing in human interest stories and sociological landscapes. At present, she is working on two photo books.